London's statues

London's statues

by

Godfrey Thompson

J M Dent & Sons Ltd

First published 1971

© Text, Godfrey Thompson, 1971

Made in Great Britain by the
Aldine Press Letchworth Hertfordshire
for J M Dent & Sons Limited
Aldine House Bedford Street London

ISBN 0 460 03939 3

Contents and map key

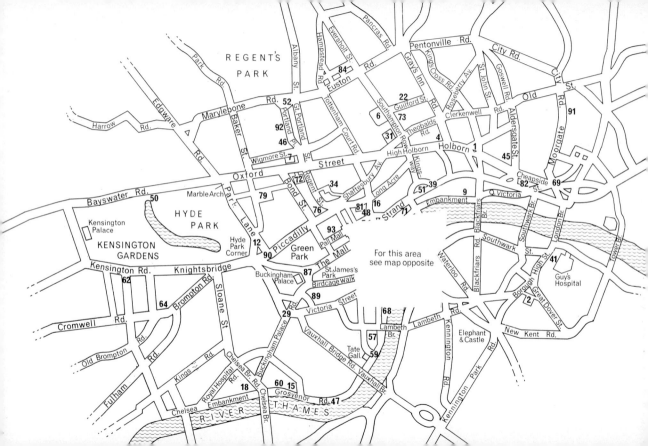

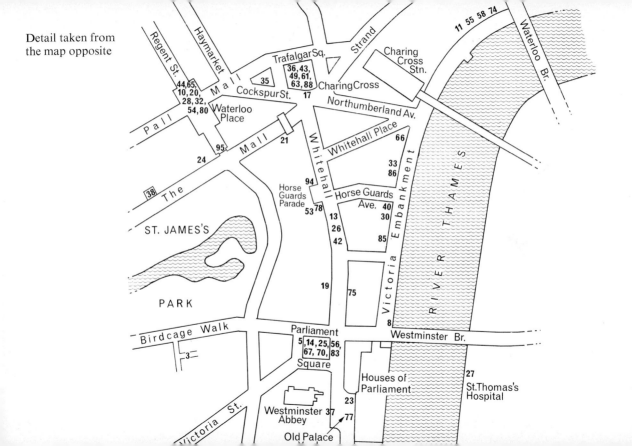

Detail taken from the map opposite

Acknowledgments

To the following institutions for permission to
reproduce plates: Department of the Environment
(plates 2, 3, 12, 13, 14, 17, 19, 20, 24, 25, 26, 32,
35, 37, 38, 40, 42, 43, 44, 50, 52, 54, 56, 57, 59,
61, 62, 65, 67, 70, 78, 80, 83, 85, 90, 93, 94); British
Tourist Authority (plates 8, 16, 21, 23, 49, 51, 63,
77, 82, 88); Radio Times Hulton Picture Library
(plates 10, 18, 30, 34, 36, 39, 48, 58, 76, 81, 91, 92,
95); The Mansell Collection (plates 4, 5, 6, 7, 15, 27,
28, 66).

Bibliography

Borenius, C. T., *Forty London Statues and Public
Monuments* (Methuen, 1926)
Cooper, C. S., *The Outdoor Monuments of London*
(The Homeland Association, 1928)
Gleichen, Lord Edward, *London's Open-Air Statuary*
(Longmans Green, 1928)
London County Council, *Return of Outdoor Memorials
in London* (1910)
Sitwell, Osbert, *The People's Album of London
Statues* (Duckworth, 1928)

Introduction

London is astonishingly rich in statues: in artistic value they may not rival those of Rome or Florence, but their range, both in centuries and in differences of style, will surprise those who take them for granted. Many of the statues are Victorian tributes to imperial greatness but others celebrate a very wide selection from Britain's hall of fame. A number, particularly of the older ones, were lost as a result of bombing or consequent rebuilding. New ones have arisen. It is to make them all more widely appreciated that this book is designed.

A statement of the book's coverage is necessary: it records and illustrates the full-length, free-standing outside statues in central London which were designed to represent historic persons, together with a briefer note on such statues in less central parts of London. It does not therefore cover:

a Statues which form part of buildings. There are a vast number of these: the Royal Exchange, the Victoria and Albert Museum, the Houses of Parliament and the Foreign Office alone would provide subjects for a separate book.
b Busts, obelisks, bas-reliefs, etc., of which again there are great numbers.
c Symbolic sculpture, including war memorials and such well known pieces as Eros in Piccadilly Circus, Physical Energy and Peter Pan, both in Kensington Gardens.

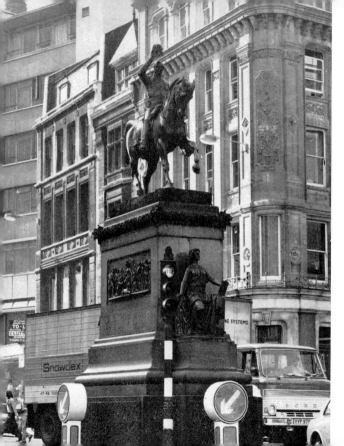

Albert, Prince Consort 1819–61.

Holborn Circus.
Sculptor Charles Bacon.
Unveiled 9th January 1874.

A bronze equestrian statue on a granite pedestal.
The Prince is shown in the uniform of a Field Marshal
and is raising his cocked hat. On the east and west
sides of the pedestal are seated female figures
representing History and Peace. On the north side is
a bas-relief in bronze showing the Prince laying
the foundation stone of the Royal Exchange. On the
south side is a similar panel showing Britannia
distributing awards to successful competitors in the
Exhibition of 1851.

Prince Albert Francis Charles Augustus Emmanuel
was the second son of Ernest, Duke of Saxe-Coburg-
Gotha and was born at Schloss Rosenau, near
Coburg, on 26th August 1819. He was educated
privately and at Brussels and Bonn. He came to
England and was betrothed to Queen Victoria in 1839.
They were married the following year. The Prince
supported the Queen in the performance of her
duties and was particularly concerned with the
advancement of art and learning. He brought forward
the idea for the International Exhibition of 1851;
a part of this exhibition was the Crystal Palace,

12

which for nearly a century was a famous London landmark. In 1857 by Royal Warrant he was made Prince Consort.

He died of typhoid fever on 14th December 1861 at Windsor Castle and was buried in St George's Chapel.

There are other statues of Prince Albert in Kensington Gardens (Albert Memorial) and Prince Consort Road, South Kensington.

Charles Bacon was a nineteenth-century English sculptor who produced mainly figures of Victorian worthies. He exhibited at the Royal Academy from 1842 to 1884.

Alfred The Great, King 849–901.
Trinity Square, Southwark.
Sculptor unknown.

A stone statue on a low pedestal, showing the figure of a king wearing flowing robes and a crown. The statue is reputed to be of King Alfred.
In *Notes and Queries*, 1921, Mr Aleck Abrahams gives details to prove that it is the statue of King

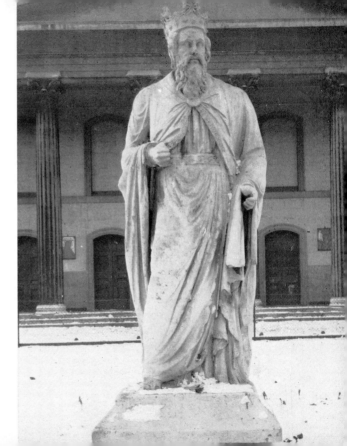

Alfred erected at the end of the fourteenth century to fill a niche in Westminster Hall, where it stood until 1825. On the expansion of the Courts of Law it was removed and placed in the newly formed Trinity Square.

Alfred, or Aelfred, was the son of Ethelwulf, King of the West Saxons, and was born at Wantage in 849. He assisted his brother Ethelred in the struggle against the Danes and became King when Ethelred fell at Merton in 871. His reign was spent in a continuing struggle against the Danes and other Scandinavian invaders. He not only saved Wessex but made it a centre of unity for the whole of England. He was the first to build a fighting force at sea and is known as the Father of the English Navy.

Alfred devoted himself also to the promotion of learning. He brought to Wessex the best scholars of the time. Men of eminence in any useful art were also encouraged and his own writings and translations form part of the country's earliest literature.

He died on 28th October 901 and was buried at New Minster (afterwards Hyde Abbey) at Winchester.

Anne, Queen 1665–1714.

Queen Anne's Gate.
Sculptor unknown.
Erected early in the eighteenth century.

A stone statue on a carved plinth which bears the words 'Anna Regina'. The Queen is shown in an elaborate gown with a tasselled girdle round her waist. She is holding a sceptre in her right hand, an orb in her left hand and is wearing a crown upon her head.

Anne was the second daughter of James II by his first wife Anne Hyde and was born at St James Palace, London, on 6th February 1665. She was educated in the Protestant faith, together with her sister Mary (who married William, Prince of Orange). In 1683 she married George, Prince of Denmark. They had several children but all died young. When James II was deposed Anne supported William of Orange and by the Declaration of Right in 1688 the succession to the throne was settled on her. She became Queen in 1702 and reigned for twelve years. During her reign the Act of Union of England and Scotland was passed and the Duke of Marlborough led the English armies to several glorious victories.

Queen Anne died at Kensington Palace on

ANNA
REGINA

1st August 1714 and was buried in Henry VII's Chapel, Westminster Abbey.

There is another statue of Queen Anne in front of St Paul's Cathedral. Made of Sicilian marble, it was erected in 1886, a copy by Richard Belt and others of the original by Francis Bird, which stood on the same spot from 1712 until it became dilapidated.

Bacon, Francis 1561–1626 (p. 16).

South Square, Gray's Inn, Holborn.
Sculptor Frederick W. Pomeroy.
Erected 1912.

A bronze statue on a marble pedestal. The figure is standing with a stick in the right hand and is bareheaded. On the pedestal are given the dates of appointments in his career and a list of his works.

Francis Bacon was the son of Sir Nicholas Bacon, Lord Keeper of the Great Seal in Queen Elizabeth's reign. He was born at York House in the Strand, London, on 22nd January 1561, educated at Trinity College, Cambridge, and admitted to Gray's Inn in 1576. He had a spectacular career, becoming in turn Solicitor-General, Attorney-General and Lord Keeper. In 1618 he was made Lord Chancellor and

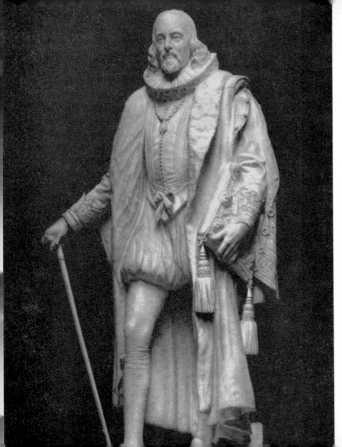

a Peer, taking the title of Baron Verulam. He became Viscount St Albans in 1621. In the same year he was charged before the House of Lords and confessed to 'corruption and neglect'. He was fined and committed to the Tower. The fine was later remitted, he was released, retired from public life and spent his remaining years in literary and philosophic work. One of the greatest English prose writers, his *Advancement of Learning*, *Novum Organum* and *Essays* have continued to be influential.

He died near St Albans on 9th April 1626.

Frederick W. Pomeroy, R.A., was born in 1857 and studied at the Royal Academy Schools, gaining a Gold Medal, and also won further medals in Chicago and Paris. His public memorial work is to be found in many parts of the country. He died in 1924.

Beaconsfield, 1st Earl of 1804–81.

Parliament Square.
Sculptor Mario Raggi.
Unveiled April 1883.

The statue is of bronze, standing on a pedestal of red granite. The statesman is in Peer's robes, with the collar of the Garter. His name is inscribed on the pedestal.

16

Every year on Primrose Day (19th April, the anniversary of his death) the statue is decorated with primroses.

Benjamin Disraeli was the eldest son of Isaac D'Israeli and was born at 6 King's Road, Bedford Row (now 22 Theobalds Road). He was privately educated and entered Lincoln's Inn in 1824. *Vivian Grey*, the first of his novels, was published in 1826. He entered Parliament, and two more novels, *Coningsby* and *Sybil*, were published but from 1848, when he became leader of the Conservative Party, he devoted himself to politics for many years. He became Chancellor of the Exchequer three times and Prime Minister twice and is best known for his initiative in acquiring control of the Suez Canal Company and for his peacemaking at the Congress of Berlin in 1876.

He was elevated to the peerage in 1876 and received the Order of the Garter in 1878. In 1880 he went into retirement, his last novel, *Endymion*, being published in the same year. He died at 19 Curzon Street, London, on 19th April 1881.

Mario Raggi was born in 1821 and died in 1907. He first exhibited at the Royal Academy in 1854 and is largely known for his portrait busts.

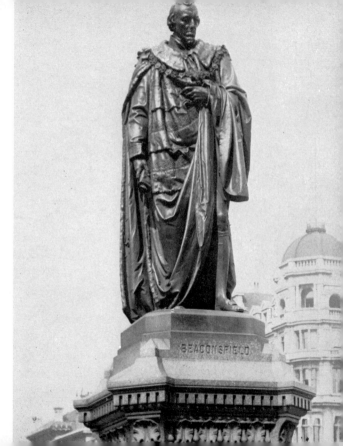

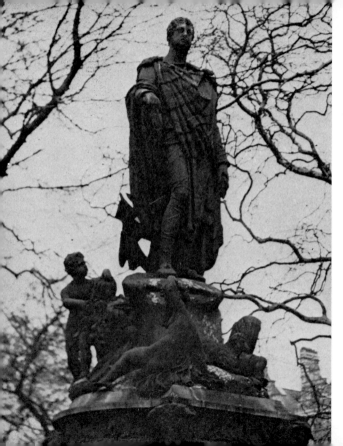

Bedford, 5th Duke of 1765–1802.

Russell Square.
Sculptor Sir Richard Westmacott.
Unveiled 3rd August 1809.

A bronze statue on a tall pedestal of granite. The Duke is shown in flowing robes, standing with his right arm resting on a plough and holding ears of corn in his left hand. At his feet there are bronze figures representing the four seasons. On two sides of the pedestal are bold reliefs in bronze, showing scenes of country life.

Francis Russell was the son of the Marquis of Tavistock and succeeded his grandfather, John Russell, 4th Duke of Bedford, in 1771. He was educated at Westminster School and Trinity College, Cambridge. He attached himself to the party of Fox, one of the friends of George, Prince of Wales, and took his seat in the House of Lords. He became a member of the original Board of Agriculture in 1793 and the first President of the Smithfield Club in 1798. A vast amount of property in central London was owned by him and he built Russell and Tavistock Squares. He also had a model farm at Woburn Abbey, Bedfordshire.

He died at Woburn on 2nd March 1802.

18

Sir Richard Westmacott, R.A., born in 1775, was the son of a British sculptor, Richard Westmacott the elder, and studied under his father. In 1793 he became a pupil of Canova. Before turning to military sculpture he made a number of famous chimney pieces. He became the Royal Academy Professor of Sculpture and was knighted in 1837. He died in 1856.

Bentinck, Lord George 1802–48.

Cavendish Square.
Sculptor Thomas Campbell.
Erected 1851.

The statue is of bronze on a pedestal of polished red granite. Lord George is standing holding a document in one hand; the other is holding his cloak.

William George Frederick Cavendish, Lord George Bentinck, was born at Welbeck Abbey on 27th February 1802. He was the second surviving son of the 4th Duke of Portland. He became private secretary to his uncle, George Canning, when the latter was Foreign Secretary and Leader of the House of Commons. He became a Major in the 2nd Life Guards in 1825 and entered Parliament as Member for King's Lynn from 1828 to 1848. Bentinck

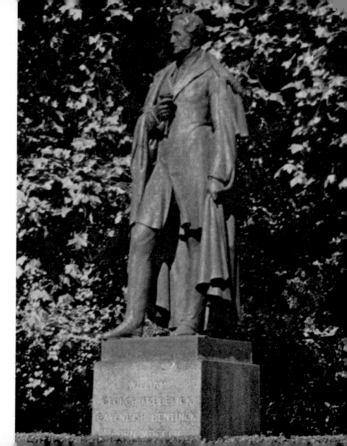

was devoted to horse racing and had his own racing stud. He introduced many improvements to racecourse management. He became Leader of the Protectionist Party which opposed Sir Robert Peel on measures to deal with corn shortage. He died on 21st September 1848.

Thomas Campbell was born in 1790. After humble beginnings he attracted the attention of a patron who sent him to the Royal Academy Schools. Later he worked in Rome for many years. He died in 1858.

Boadicea, Queen Died A.D. 61.

Victoria Embankment.
Sculptor Thomas Thornycroft, after designs by J. C. Jackson.
Erected 1902.

A very large bronze statuary group on a pedestal of brick and granite faced with bronze. The Queen and her two daughters are in a war chariot drawn by two horses. The pedestal bears the inscription 'Boadicea (Boudicca) Queen of the Iceni who died A.D. 61 after leading her people against the Roman invaders'. Added are these lines from Cowper:

> Regions Caesar never knew
> Thy posterity shall sway.

20

Boadicea was the wife of Prasutagus, King of the Iceni. He bequeathed his kingdom to be shared: half to his two daughters and half to the Roman Emperor Nero. When he died, however, the Romans took the whole, scourged Boadicea and violated her daughters. In revolt Boadicea led many thousands of her tribesmen and burnt the Roman colonies at Colchester, St Albans and London, killing many Romans. The Roman Governor Suetonius Paulinus returned from Anglesey on hearing of this and in a great battle defeated the Britons. Boadicea took poison in A.D. 61 to escape capture.

Thomas Thornycroft was born in 1815 and died in 1885. Chiefly remembered now as the father of Sir (William) Hamo Thornycroft, he was a capable and industrious sculptor and a number of his statues and busts are to be seen in London.

Brunel, Isambard Kingdom 1806–59.
Victoria Embankment.
Sculptor Baron Carlo Marochetti.
Erected 1877.

The bronze statue shows Brunel standing with a pair of dividers in his hand. The pedestal and screen of Portland stone were designed by Norman Shaw.

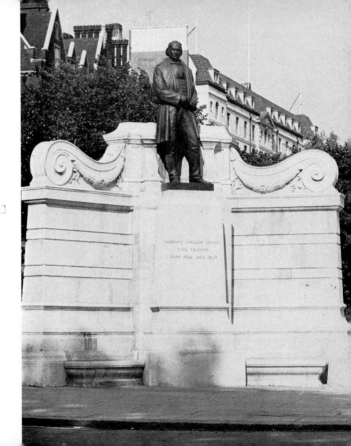

Isambard Kingdom Brunel was the only son of
Sir Marc Isambard Brunel, civil engineer. He was
born in Portsmouth, educated privately and in Paris
and then entered his father's firm. He was resident
Engineer of the Thames Tunnel in 1826, appointed
Engineer to the Great Western Railway in 1833 and
planned the broad-gauge railway line from London
to Bristol. He designed the very fine Clifton
Suspension Bridge near Bristol. Brunel was also a
successful naval architect and designed the three
steamships *Great Western*, *Great Britain* and *Great
Eastern*. He constructed many docks and bridges
and invented improvements in artillery. In 1859 he
was taken ill when on board the *Great Eastern* and
died on 15th September 1859.

Baron Carlo Marochetti, R.A., was an Italian who
trained in Paris and Rome, becoming rich in honours
as a sculptor, and came to England in 1848. He did
important work here, particularly under the patronage
of the royal family, and is notable for the vivacity
of his portrait sculpture. Richard Cœur de Lion
(see page 99) is considered to be his masterpiece.

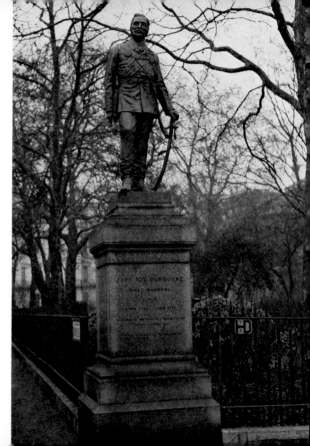

Burgoyne, Sir John, 1st Baronet 1782–1871.

Waterloo Place.
Sculptor Sir Joseph Edgar Boehm.

Erected by his fellow officers of the Royal Engineers in 1877.

A bronze statue on a grey granite pedestal. The Field Marshal is shown standing, bareheaded, his left hand resting on his sword and his right hand holding his baton. He is wearing a tunic and sashes and is booted and spurred. At the base are inscribed the words from *Coriolanus*: 'How youngly he began to serve his country. How long continued.' His name, rank and dates are also given.

John Fox Burgoyne was the illegitimate son of John Burgoyne, General and dramatist. He was born on 24th July 1782 and educated at Eton and Woolwich. In 1798 he entered the Royal Engineers and served in Malta, Sicily and Egypt. He served under Sir John Moore in the Spanish Expedition of 1808–9 and under Wellington in the Peninsular War. Later he was in the American campaign and Commander of Engineers in France and Portugal. He became a Major-General and was knighted in 1838. He served in the Crimean War, becoming a General in 1855 and a Baronet in 1856. Burgoyne was appointed Constable of the Tower of London in 1865 and Field Marshal in 1868. He died in London on 7th October 1871.

Sir Joseph Edgar Boehm, Bt, R.A., was born in Austria in 1834 and came to England at the age of fourteen. He produced an enormous amount of important work, particularly of the statesmen and warriors of his day, and became one of the most fashionable sculptors of the Victorian era. He died in 1890.

Burns, Robert 1759–96 (p. 24).

Victoria Embankment Gardens.
Sculptor Sir John Steell.
Unveiled 26th July 1884.

A bronze statue on a granite pedestal and base. The poet is shown seated on the broken stump of a tree, in the act of composing. He is wearing rustic clothes and beside him lie a scroll and a broken ploughshare. The inscription says: 'The poetic genius of my country found me at the plough—and threw her inspiring

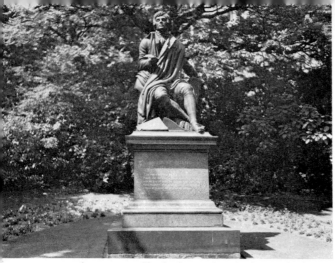

Much of his life was spent farming, but he eventually gave this up to become an exciseman. The success of his poems gained him access to literary circles in Edinburgh and his convivial nature to Masonic and drinking clubs. In 1788 he married Jean Armour, one of a number of girls whom he courted and who were the inspiration of some of his most beautiful poems. He died in Dumfries on 21st July 1796.

Sir John Steell was born in Aberdeen in 1804. He was apprenticed to a woodcarver and then studied in Rome. Later he became a member of the Royal Scottish Academy and was appointed Sculptor to the Queen in Scotland. He is best known for his figure of Sir Walter Scott in Princes Street, Edinburgh. His works are seen in many countries. He died in 1891.

Byron, 6th Baron 1788–1824.
Hamilton Gardens, Hyde Park.
Sculptor R. C. Belt.
Unveiled 24th May 1880.

The statue is of bronze and is mounted on a marble pedestal which was a gift of the Greek government. The poet is seated on a rock in an attitude of meditation, with his dog by his side. The pedestal bears his name.

mantle over me. She bade me sing the loves, the joys, the rural scenes and rural pleasures of my native soil, in my native tongue. I tuned my artless notes as she inspired.'

Robert Burns was the eldest son of a cottar and was born at Alloway, Ayrshire, on 25th January 1759. He was educated by his father and worked as a farm labourer. By 1777 he had learnt surveying, started to read widely and composed his first verses.

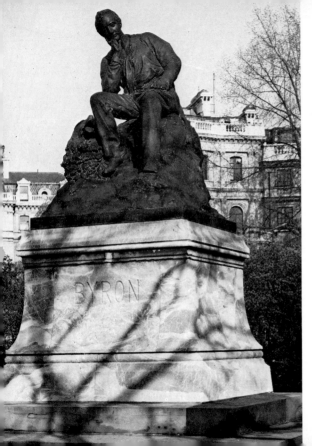

George Gordon Byron was born in London on 22nd January 1788. He was the son of profligate Captain John Byron and Catherine Gordon of Gight and unexpectedly succeeded to the title when he was ten years old. He was educated at Harrow and Trinity College, Cambridge, and then travelled extensively on the Continent. He began writing early, his first works being completed when he was still at university, and the publication of his poems brought him fame and adulation. In 1815 he married Anne Isabella Milbanke but they were separated a year later and he left England, his various affairs offending public opinion of the time. For the next few years he lived in Switzerland and Italy and completed what are probably his best known works, *Childe Harold* and *Don Juan*. In 1823 Byron went to join the Greek insurgents in their struggle for independence and died of fever at Missolonghi on 19th April 1824. His body was brought back to England and buried at Hucknall Torkard in Nottinghamshire.

Richard C. Belt exhibited from 1873 to 1885 at the Royal Academy, being famous for his busts of Victorian worthies.

Cambridge, 2nd Duke of 1819–1904.

Whitehall.

Sculptor Adrian Jones.

Unveiled 15 June 1907.

A bronze equestrian statue with a pedestal of grey Dartmoor granite. The Duke is shown in the full dress uniform of a Field Marshal with orders and medals. The pedestal was designed by John Belcher in collaboration with the sculptor and has bronze panels in low relief of men of the 17th Lancers and Grenadier Guards. Inscriptions read 'Field Marshal H.R.H. George, Duke of Cambridge, G.C.B.' and 'Commander-in-Chief of the British Army 1856–95'.

George, Duke of Cambridge, son of Adolphus Frederick, 1st Duke of Cambridge, was born in Hanover and came to England in 1830 when he was eleven years old. He was a grandson of George III and a cousin of Queen Victoria. He joined the British Army in 1839. He took part in the Crimean War, being present at the battles of Alma and Inkerman. In 1856 he was made Commander-in-Chief, an office which he held for many years until forced to resign in 1895. He died on 17th March 1904.

Captain Adrian Jones was born in 1845. After twenty-three years in the cavalry, including three campaigns, he turned to sculpture, specializing in

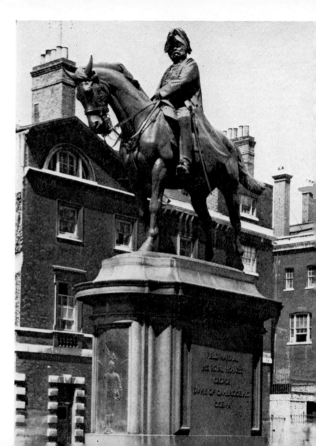

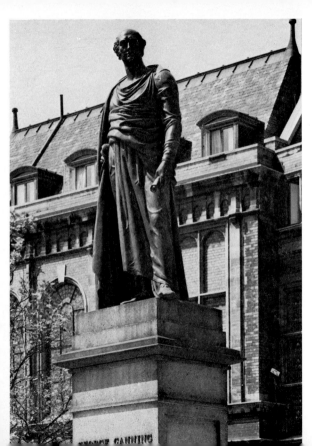

equestrian statues, of which there are a number of his examples in London. He excelled in both professions. His work includes the Quadriga at Hyde Park Corner, the Carabineers on Chelsea Embankment and the Cavalry at Stanhope Gate. He died in 1938.

Canning, George 1770–1827.

Parliament Square.
Sculptor Sir Richard Westmacott.

Erected May 1832 in Palace Yard, it was removed to its present position in April 1867.

A bronze statue on a pedestal of grey granite. Canning is shown robed and holding a scroll in his left hand. The pedestal bears his name.

George Canning, the son of a barrister, was born in London on 11th April 1770 and brought up by an uncle, a Whig banker. He was educated at Eton and Christ Church, Oxford, and entered Lincoln's Inn in 1791. His parliamentary career began when he became Member for Newport in 1794. Under Pitt's administrations he was made Under Secretary for Foreign Affairs, Paymaster-General and Treasurer of the Navy. He refused office under Grenville, Spencer Perceval and Lord Liverpool, but accepted office in Lord Liverpool's later administrations. He fought a

duel with Castlereagh. Canning was a firm supporter of the movement for freedom against autocracy abroad. He became Prime Minister in 1826 and Chancellor of the Exchequer the following year, but held office for only a few months. He died on 8th August 1827.

For sculptor see page 19.

Carlyle, Thomas 1795–1881.

Chelsea Embankment Gardens.
Sculptor Sir Joseph Edgar Boehm.
Unveiled 26th October 1882.

The statue is of bronze on a pedestal of red granite. Carlyle is shown wearing a loose robe and sitting in an armchair, his legs crossed and his hands folded. The pedestal is inscribed with his name and the dates and places of his birth and death.

Thomas Carlyle was born in Ecclefechan, Dumfriesshire, of peasant stock, and educated at Annan Academy and Edinburgh University. He became a schoolmaster but turned to literary work. His *Life of Schiller* was published in book form in 1825. The following year he married Jane Welsh and for a number of years lived in her moorland farmhouse at Craigenputtock in Nithsdale. Here he

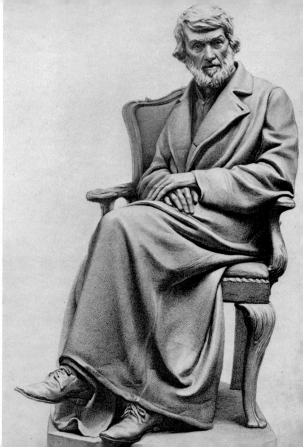

completed *Sartor Resartus* and the first part of the *French Revolution*. He moved to London to a house in Cheyne Row, Chelsea, in 1834 and continued to write during the next thirty years. He spent fourteen years preparing *Frederick the Great*, which was completed in 1865. His wife died soon after and from then on he wrote little of importance. He died in Cheyne Row on 5th February 1881.

For sculptor see page 23.

Cavell, Edith 1865–1915.

St Martin's Place.

Sculptor Sir George Frampton.

Unveiled by Queen Alexandra on 17th March 1920.

The marble statue of Edith Cavell, who is shown wearing her nurse's uniform and cape, stands on a plinth in front of a tall block of grey granite, on which are inscribed the words: 'Humanity', 'Sacrifice', 'Fortitude', 'Devotion'. The plinth bears the inscription: 'Edith Cavell. Brussels. Dawn. October 12th 1915. Patriotism is not enough. I must have no hatred or bitterness for anyone.' Crowning the monument is a woman shielding a child, below which is a scroll inscribed 'For King and Country', and on the back is a lion in relief and the words 'Faithful unto Death'.

29

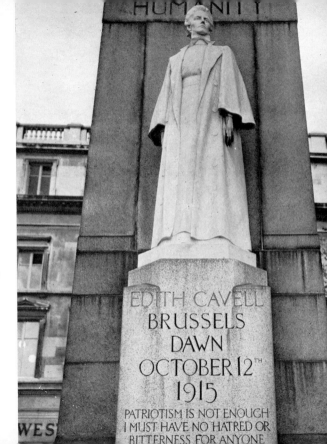

Edith Cavell was born on 4th December 1865 at Swardeston in Norfolk. Her education was completed in Brussels and she trained as a nurse at the London Hospital. In 1907 she was appointed Matron of the Berkendael Medical Institute in Brussels and was put in charge of the Institute when it became a Red Cross Hospital in 1914. On 5th August 1915 she was arrested by the Germans and charged with assisting Allied soldiers to escape. She was brought to trial on 7th October, condemned to death by court-martial and shot in the early morning of 12th October.

In May 1919 Edith Cavell's body was brought to England and, after a memorial service in Westminster Abbey, was buried in the precincts of Norwich Cathedral.

Sir George James Frampton, R.A., exhibited at the Royal Academy from 1881 and is particularly well known for his work, which adorns many public buildings. He produced statues of Queen Victoria for several towns and designed a number of Commonwealth medals. He was born in 1860 and died in 1928.

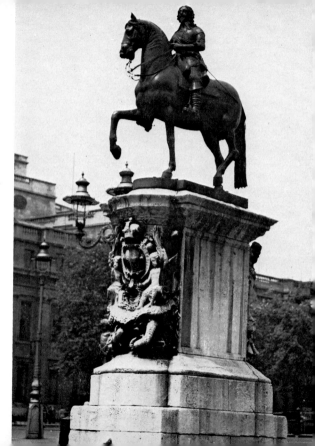

completed *Sartor Resartus* and the first part of the *French Revolution*. He moved to London to a house in Cheyne Row, Chelsea, in 1834 and continued to write during the next thirty years. He spent fourteen years preparing *Frederick the Great*, which was completed in 1865. His wife died soon after and from then on he wrote little of importance. He died in Cheyne Row on 5th February 1881.

For sculptor see page 23.

Cavell, Edith 1865–1915.

St Martin's Place.

Sculptor Sir George Frampton.

Unveiled by Queen Alexandra on 17th March 1920.

The marble statue of Edith Cavell, who is shown wearing her nurse's uniform and cape, stands on a plinth in front of a tall block of grey granite, on which are inscribed the words: 'Humanity', 'Sacrifice', 'Fortitude', 'Devotion'. The plinth bears the inscription: 'Edith Cavell. Brussels. Dawn. October 12th 1915. Patriotism is not enough. I must have no hatred or bitterness for anyone.' Crowning the monument is a woman shielding a child, below which is a scroll inscribed 'For King and Country', and on the back is a lion in relief and the words 'Faithful unto Death'.

29

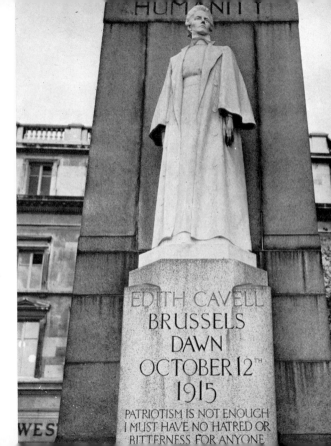

Edith Cavell was born on 4th December 1865 at Swardeston in Norfolk. Her education was completed in Brussels and she trained as a nurse at the London Hospital. In 1907 she was appointed Matron of the Berkendael Medical Institute in Brussels and was put in charge of the Institute when it became a Red Cross Hospital in 1914. On 5th August 1915 she was arrested by the Germans and charged with assisting Allied soldiers to escape. She was brought to trial on 7th October, condemned to death by court-martial and shot in the early morning of 12th October.

In May 1919 Edith Cavell's body was brought to England and, after a memorial service in Westminster Abbey, was buried in the precincts of Norwich Cathedral.

Sir George James Frampton, R.A., exhibited at the Royal Academy from 1881 and is particularly well known for his work, which adorns many public buildings. He produced statues of Queen Victoria for several towns and designed a number of Commonwealth medals. He was born in 1860 and died in 1928.

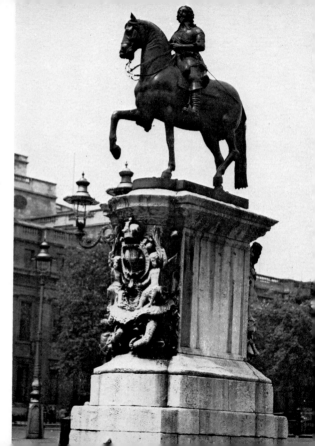

Charles I, King 1600–49.

Charing Cross.

Sculptor Hubert Le Sueur.

A bronze equestrian statue on an oval-shaped pedestal of freestone mounted on blocks of the same. The King is shown in armour and is bareheaded. There are carved emblems on the pedestal below the plinth on which the horse rests. The statue was cast in 1633 and was originally intended for the garden of Lord Weston, afterwards Earl of Portland, at Roehampton. During the Commonwealth it came into the hands of John Rivett, a brazier, who refused to return it to the Earl of Portland. Eventually it came into the possession of the Crown and was erected on the site of the original Charing (Eleanor) Cross sometime between 1675 and 1677.

Charles was the second son of James I of England (and VI of Scotland) and Anne of Denmark and was born at Dunfermline on 19th November 1600. He became heir apparent on the death of his brother in 1612 and King in 1625. In the same year he married Princess Henrietta Maria of France.

 Charles I's reign was turbulent, Parliament being opposed to his various and mainly unsuccessful undertakings in politics and religion and particularly to his insistence on the Divine Right of Kings. In 1629 he dissolved Parliament and ruled alone for eleven years. When Parliament was reinstated the disputes continued and developed into civil war. This raged throughout the country for seven years, ending with Charles's trial and execution at Whitehall on 30th January 1649.

Hubert Le Sueur, born in Paris in 1580, became Sculptor to the King of France in 1619 and entered the service of Charles I in 1630. He returned to France later but died in London in 1670.

Charles II, King 1630–85 (p. 32).

Chelsea Hospital.

Sculptor Grinling Gibbons.

Erected *circa* 1692.

A bronze statue, on a low stone pedestal, showing the King in Roman costume and holding a baton in his right hand. The statue is wreathed with oak leaves on Oak Apple Day each year: 29th May. His name is inscribed on the pedestal. The statue is a companion to that of James II which stands outside the National Gallery.

avert Charles I's execution in 1649. In 1651 he was crowned King of Scotland at Scone. He marched southwards with his army, was defeated by Cromwell at Worcester, hid in an oak tree to avoid capture and then fled to France. After living in poverty in Paris for some time he set up court in Bruges and then Brussels but it was not until 1660 that he was recalled to London. He was crowned in 1661 and in 1662 married Catherine of Braganza. During his uneasy reign there occurred the defeats in the Dutch wars as well as the Plague and the Great Fire of London. He died on 6th February 1685, acknowledging himself a Roman Catholic on his deathbed.

Grinling Gibbon(s), a true genius, was born in Rotterdam in 1648 and came to England in 1667. He was discovered by John Evelyn, the diarist, and subsequently became the greatest of all wood-carvers. He lived in the City, dying there in 1721.

Clive, Robert, 1st Baron 1725–74.

King Charles Street.
Sculptor John Tweed.

A bronze statue on a tall pedestal of Portland stone. Lord Clive is shown standing, in military uniform. He is bareheaded and holding a scroll in his right hand, his left hand resting on his sword. On three

Charles, the second son of Charles I and Henrietta Maria, was born at St James's Palace, London, on 29th May 1630 and was created Prince of Wales in about 1638. In the war he joined his father's cause and was present at the battle of Edgehill but fled to France after the defeat at Naseby. He tried to

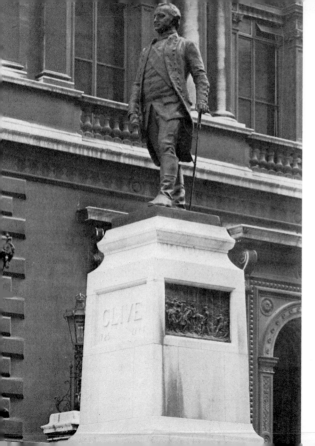

sides of the pedestal there are bronze bas-reliefs depicting: the siege of Arcot; the eve of Plassey; the grant of Bengal, Behar and Orissa. The statue was placed in the gardens of Gwydyr House, Whitehall, in 1912 and removed to its present site in 1916.

Robert Clive was born at Styche, Shropshire, on 29th September 1725. The son of an impoverished squire, he attended various schools and was then offered a writership in the East India Company. By the time he reached Madras he was in debt and friendless and tried to shoot himself. He was taken prisoner by the French but escaped, became an ensign and showed great bravery at the siege of Pondicherry. He had considerable success in his military career and first achieved fame in his exploits at Arcot. His greatest achievement was the battle of Plassey in 1757. He returned to England in 1759, entered Parliament as Member for Shrewsbury and in 1762 was created Baron Clive in the Irish peerage. He became Governor of Bengal in 1765 but a year later returned in poor health to England where he faced charges of misuse of power. Parliament did not condemn him but the slur on his character may have led to his suicide on 22nd November 1774.

For sculptor see page 118.

33

Clyde, Sir Colin Campbell, 1st Baron 1792–1863.

Waterloo Place.

Sculptor Baron Carlo Marochetti.

Erected 1867.

A bronze statue on a pedestal of shiny red granite with mouldings of bronze and a grey granite base. Lord Clyde is standing with a helmet in his left hand, the thumb of his right hand hooked in a telescope strap. Depicted in bronze on the grey granite base is Britannia, seated on a lion, crowned with laurel and holding an olive branch.

Colin Campbell was the son of Colin McIver, a carpenter, and was born in Glasgow on 20th October 1792. He took the name of Campbell because of an error of the Duke of York in 1807. He became an ensign and served in Portugal under Sir John Moore and showed great courage when serving in the Peninsular Campaign. He also served in Nova Scotia, the West Indies, China and India, and in 1854 as Major-General commanded the Highland Brigade at the battle of Alma in the Crimea. He was Commander-in-Chief in India from 1857 to 1860 and during this time suppressed the Indian Mutiny. In 1858 he was created Baron Clyde and made Field Marshal in 1862. He died on 14th August 1863 and was buried in Westminster Abbey. For sculptor see page 22.

Cook, Captain 1728–79.

The Mall.

Sculptor Sir Thomas Brock.

Unveiled by H.R.H. Prince Arthur of Connaught on 7th July 1914.

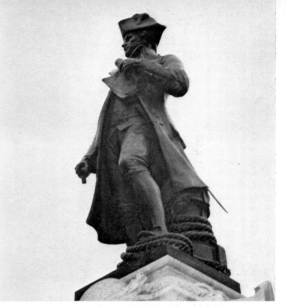

A bronze statue on a pedestal of stone. The Captain is shown in naval uniform standing in front of a capstan. He is holding a telescope in his right hand and a scroll in his left. The pedestal is decorated with naval emblems. There is an inscription: 'Circumnavigator of the Globe, Explorer of the Pacific Ocean, he laid the foundation of the British Empire in Australia and New Zealand.'

James Cook was a labourer's son and was born at Marton in Yorkshire on 27th October 1728. He went to sea, first as a merchant seaman and then with the Navy. He surveyed the St Lawrence at the siege of Quebec. By 1768 he had achieved the rank of Lieutenant and sailed in the *Endeavour* for Tahiti, round Cape Horn. He charted the coasts of New Zealand, the east coasts of Australia and part of New Guinea, returning by the Cape of Good Hope. In 1771 he set sail in the *Resolution*. On this journey he visited many Pacific islands. By applying new methods of hygiene he avoided scurvy and fever among his crew. He attempted to discover a north-west passage in 1776, and discovered the Sandwich Islands. He endeavoured to chart the Pacific coast of North America and was murdered by natives in Hawaii on 14th February 1779. An obelisk was erected in 1874 at the place where he was killed.

For sculptor see page 96.

Coram, Thomas 1668(?)–1751.

Brunswick Square.

Sculptor W. McMillan.

Erected 1963.

The statue is of bronze on a stone pedestal. Coram is
shown seated, wearing a flowing wig and a broad-
tailed coat, holding the charter of the hospital in one
hand. Hogarth's portrait was used for a likeness and
the statue replaces that by W. Calder Marshall which
was erected in 1752.

Thomas Coram was born at Lyme, Dorset, in about
1668. He became a merchant sea captain, trading
between England and America, and then a shipbuilder
at Taunton, Massachusetts. By 1720, however, he
had become a merchant in London. Appalled by the
number of infants who were abandoned, he worked
for the establishment of a Foundling Hospital in
London and endeavoured for many years to bring
this about. He obtained a charter and the hospital
was opened in 1745. Coram also worked to promote
the settlement and colonization of Georgia and
Nova Scotia. Having used all his money for charity
he ended his days living on a small annuity which
was raised by public subscription. He died on
29th March 1751 in London.

For sculptor see page 55.

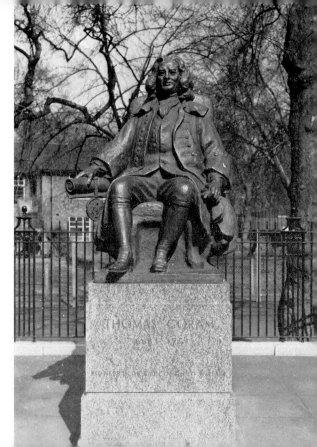

Cromwell, Oliver 1599–1658.

Old Palace Yard, Westminster.

Sculptor Sir (William) Hamo Thornycroft.

Unveiled 14th November 1899.

A statue of bronze on a pedestal of Portland stone which bears his name and dates of birth and death. Cromwell is shown in military attire, bareheaded, with his right hand clenched on the hilt of his sword and his left hand clasping a Bible. At the base of the pedestal there is a reclining bronze lion.

Oliver Cromwell was born at Huntingdon on 25th April 1599. He was educated at Sidney Sussex College, Cambridge, and is said to have been a member of Lincoln's Inn. He became Member of Parliament first for Huntingdon and then for Cambridge. When the Civil War broke out he fought at Edgehill and afterwards formed his troop of horse into a regiment. This strictly disciplined force helped to gain victories at the battles of Marston Moor in 1644 and Naseby in 1645 and became known as the Ironsides. Cromwell suppressed further risings in Wales, Scotland and Ireland and defeated Charles II at Worcester in 1651. In 1653 he was created Lord Protector of the Commonwealth. During his control he carried out a successful foreign policy and stabilized affairs in England. He died at

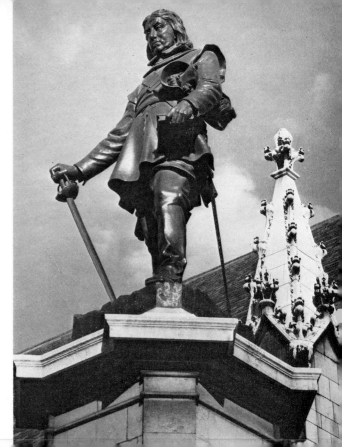

Whitehall on 3rd September 1658 and was buried in Westminster Abbey. After the Restoration his body was disinterred and hanged on the gallows at Tyburn.

Sir (William) Hamo Thornycroft, R.A., was the son of Thomas and Mary Thornycroft, who were also sculptors. He studied at the Royal Academy, obtaining Gold Medals from both this Academy and that of Munich, and from the Royal Society of British Sculptors. Most of his statues were erected in London. He died in 1925.

Curzon, 1st Marquess 1859–1925.

Carlton House Terrace.

Sculptor Sir Bertram Mackennal.

Unveiled 26th March 1931.

A bronze statue on a stone pedestal. Curzon is shown standing, bareheaded, and holding the folds of a large robe which is wrapped about him. The inscription on the pedestal gives his name and awards, dates of birth and death, and says: 'Erected by his friends in recognition of a great public life.'

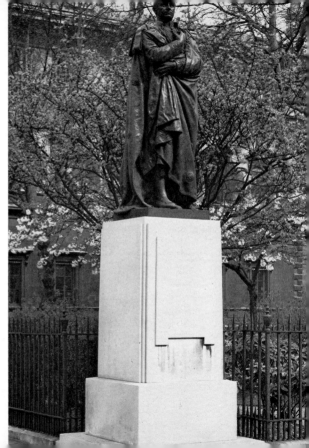

George Nathaniel Curzon was born on 11th January 1859 at Kedleston Hall, Derbyshire, and was the eldest son of the 4th Baron Scarsdale. He was educated at Eton and Balliol College, Oxford. From this time he suffered from curvature of the spine which gave him pain all his life. He became a Member of Parliament in 1886. He travelled extensively, particularly in the East, and became an authority on Asiatic affairs. In 1895 he married Mary Leiter, the daughter of a United States millionaire. He was made Viceroy of India in 1898 and created Baron Curzon of Kedleston. His term of office was a time of achievement and splendour but ended in frustration in 1905 after a quarrel with Lord Kitchener. He was created an Earl in 1911. Returning to politics he served in the Inner War Cabinet, became Leader of the House of Lords and twice held office as Foreign Secretary. In 1916 he was made a Knight of the Garter and created Marquess in 1921. He died on 20th March 1925 in London.

Sir (Edgar) Bertram Mackennal, R.A., was born in Melbourne in 1863 and studied there and in London and Paris. He produced a number of fine public works and was knighted in 1921.

Derby, 14th Earl of 1799–1869 (p. 40).

Parliament Square.
Sculptor Matthew Noble.
Unveiled 11th July 1874.

A bronze statue on a red granite pedestal. Lord Derby is shown standing, in Peer's robes and holding a dispatch in his left hand. The pedestal has bronze bas-reliefs depicting Lord Derby: speaking to the House of Commons on the slave question; at a Cabinet meeting; at a meeting of the Lancashire Relief Committee; being inaugurated as Chancellor of Oxford University.

Edward George Geoffrey Smith Stanley was the son of Edward Smith Stanley, 13th Earl of Derby. He was born at Knowsley, Prescot, on 29th March 1799 and educated at Eton and Christ Church, Oxford. He had a long parliamentary career during which he contributed much to the stabilizing of affairs in Ireland. He introduced the Reform Bill for Ireland, the Irish Education Act and instituted an Irish Board of Works and other measures. In 1833 as Colonial Secretary he carried an Act for the abolition of slavery. He entered the House of Lords as Lord Stanley of Bickerstaffe and acted as Leader of the newly formed Conservative Party, succeeding to the earldom in 1851. Three times during his career he

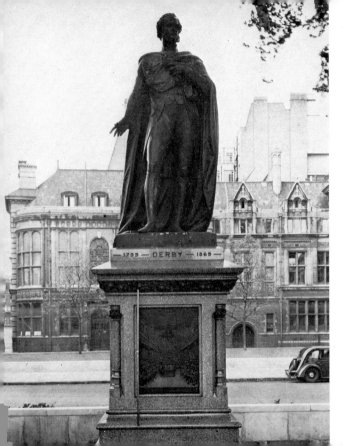

became Prime Minister. Apart from parliamentary affairs Lord Derby was also devoted to classical scholarship and to sport. He died at Knowsley on 23rd October 1869.

Matthew Noble, a prolific and much respected sculptor, was born in Yorkshire in 1817 and first exhibited at the Royal Academy in 1845. He produced the Wellington monument in Manchester in 1856. He died in 1876.

Devonshire, 8th Duke of 1833–1908.

Whitehall.

Sculptor H. Hampton.

Erected by his friends in 1910.

A bronze statue on a stone pedestal. The Duke is shown standing, bareheaded and in Peer's robes. The pedestal bears the ducal arms and his name and dates.

Spencer Compton Cavendish was the eldest son of the 7th Earl of Devonshire and was born on 23rd July 1833. He was educated privately and at Trinity College, Cambridge. His political career began when he was elected Liberal Member of Parliament for North Lancashire in 1857. He held a number of Government posts under Gladstone, including that of

40

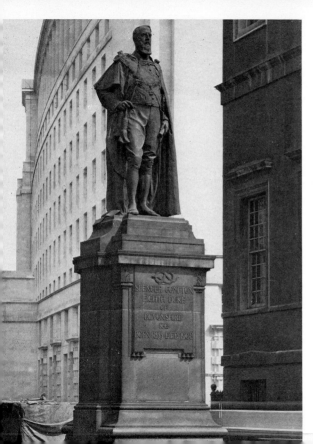

Postmaster-General and that of Secretary of State for India. Later, however, he was strongly against Gladstone's Home Rule policy and in opposition formed the Liberal Unionist Party with Joseph Chamberlain. Three times during his career he was asked to become Prime Minister but each time he declined. In 1891 he succeeded his father as Duke of Devonshire. He died at Cannes on 24th March 1908.

Herbert Hampton was born in 1862 and died in 1929. He produced a great number of statues and busts of royal personages.

Edward VI, King 1537–1553 (p. 42).
St Thomas's Hospital.
Sculptor Peter Scheemakers.

First erected in 1737, its position was altered in 1739 and again when the hospital moved from Southwark in 1870–1. It is at present in store but will be re-erected when rebuilding is completed.

A statue of bronze on a pedestal of marble. It was modelled after the picture by Holbein at Kensington Palace. There are three steps leading to the pedestal, which bears a long inscription in Latin and English.

The boy-King is shown standing robed and with his right hand extended.

Edward was the son of Henry VIII and Jane Seymour and was born on 12th October 1537. He was educated by learned men of the time, notably Sir John Cheke and Roger Ascham, and crowned King in 1547 when he was nine years old. Dominated at first by the Duke of Somerset, Lord Protector, and later by the Duke of Northumberland, who had Somerset beheaded, he was induced to name Lady Jane Grey as his successor. His reign is chiefly notable for his support of the Protestant religion and the continuation of the Reformation in England. He died on 6th July 1553 at Greenwich.

Peter Scheemakers, the son of an Antwerp sculptor of the same name, was born in 1691. He worked in Copenhagen and studied in Rome, then worked in London in collaboration with L. Delvaux, becoming famous for copying classical statues and producing a great number of memorials. He died in 1781.

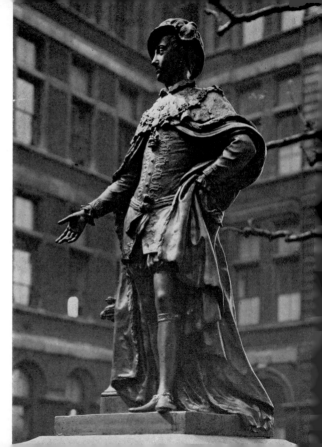

Edward VII, King 1841–1910.

Waterloo Place.
Sculptor Sir Bertram Mackennal.

Unveiled 20th July 1921.
A large bronze equestrian statue on a granite pedestal.
The King is shown in military uniform. The pedestal
is decorated with the royal coat of arms and bears
the inscription 'Edwardus VII, Rex, Imperator,
1901–1910'. The architect was Sir Edwin Lutyens.

Albert Edward was the eldest son of Queen Victoria
and was born at Buckingham Palace on 9th
November 1841. He was educated at Edinburgh,
Christ Church, Oxford, and Trinity College,
Cambridge. In 1863 he married Princess Alexandra
of Denmark. During his reign the Entente
Cordiale with France was formed and he became
known as 'Edward the Peacemaker'. Although
his personal life had been criticized, his accession
saw a revival of the pageantry and lightness
of heart which had been subdued during Queen
Victoria's long period of mourning for the Prince
Consort. He died on 6th May 1910 at Buckingham
Palace and is buried in St George's Chapel, Windsor.

There are several other statues of King Edward in
London.

For sculptor see page 39.

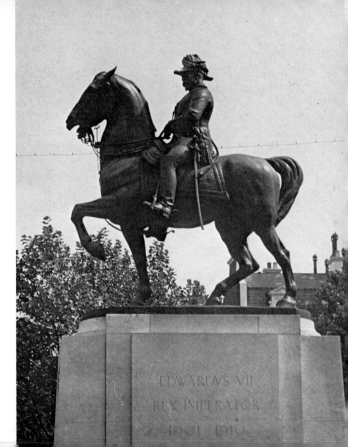

Foch, Marshal 1851–1929.

Buckingham Palace Road.
Sculptor Sir Jacob Epstein.
Unveiled 1930.

A bronze equestrian statue on a stone pedestal. The Marshal is shown in uniform. On the pedestal is the inscription: 'I am conscious of having served England as I served my own country.' His rank and honours are also given.

Ferdinand Foch, the son of a civil servant, was born at Tarbes in the Haute-Pyrénées on 2nd October 1851. He was educated by Jesuits and at the École Polytechnique, Nancy. He entered the French Army and distinguished himself at cavalry school both as a student and a horseman. He attended the École de Guerre three times, as student, lecturer and director. Throughout World War I he served his country as Corps and Army Commander and in 1918 became Supreme Commander of the Allied Forces on the Western Front. He was made a Marshal of France after the war and a British Field Marshal in 1919. In 1920 he was appointed President of the Allied Military Committee of Versailles to supervise the carrying out of armistice terms. He died in Paris on 20th March 1929 and was buried at Les Invalides.

For sculptor see page 107.

Forster, William Edward 1818–86.

Victoria Embankment Gardens.
Sculptor H. Richard Pinker.
Unveiled 1st August 1890.

A bronze statue on a pedestal of grey granite. Forster is standing with a book in his left hand, his right hand behind him. He is bareheaded and wearing a short coat. There is an inscription: 'To his wisdom and courage England owes the establishment throughout the land of a national system of Elementary Education.' His name and dates are also given.

William Edward Forster was born at Bradpole, Dorset, and educated at Quaker schools in Bristol and Tottenham. He entered the woollen trade at Bradford and married a daughter of Dr Arnold in 1850. He became Liberal Member of Parliament for Bradford in 1861 and remained so until his death twenty-five years later. A Vice-President of the Council in Gladstone's first ministry, he carried the Endowed Schools Bill and the Elementary Education Bill. He was appointed Chief Secretary for Ireland in 1880 but failed in his endeavours to bring about further reforms and resigned his office after two years. He died on 5th April 1886.

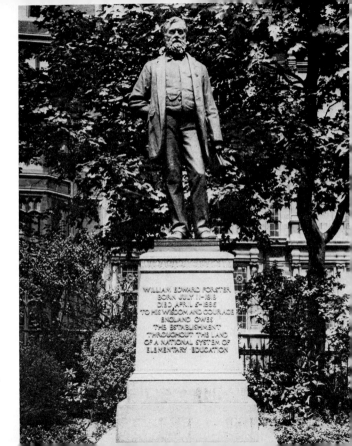

45

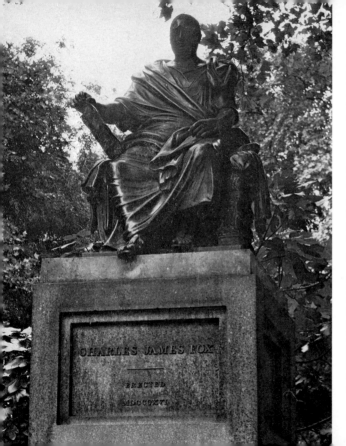

Henry Richard Pinker first exhibited at the Royal Academy in 1875 and was a successful sculptor who created a large number of portrait busts of late Victorian scholars. He did comparatively few statues. Later in life he assumed the name of Hope-Pinker. He was born in 1849 and died in 1927.

Fox, Charles James 1749–1806.

Bloomsbury Square.
Sculptor Sir Richard Westmacott.
Erected 1816.

A bronze statue on a granite pedestal. The statesman is shown seated, wearing the robes of a Roman senator and holding in his hand a roll of the Magna Carta.

Charles James Fox was the third son of Henry Fox, 1st Lord Holland, and was born in Conduit Street, London, on 24th January 1749. He was educated at Eton and Hertford College, Oxford, and had a turbulent parliamentary career. He joined North's administration but was dismissed. He opposed North's American policy and later became Foreign Secretary under Rockingham. In 1786 he moved the impeachment of Warren Hastings but is most famous as the opponent of Pitt during the early years of the war with France, when he supported the cause of the

46

Revolutionaries. At the same time his friendship with the Prince of Wales made George III his determined enemy. Although he was a member of Johnson's 'Literary Club' his private life was of dissipation and gambling, which accentuated his continued financial difficulties. Even this, however, could not lose him the regard in which he was held for his oratory, the loftiness of his thought and his courage. He died at Chiswick on 13th September 1806 and was buried in Westminster Abbey.

For sculptor see page 19.

Franklin, Sir John 1786–1847.
Waterloo Place.
Sculptor Matthew Noble.
Unveiled November 1866.

A bronze statue on a pedestal of polished granite. Franklin is shown in the act of telling his crew that the North-West Passage is discovered. The inscription says: 'To the great Arctic Navigator and his brave companions who sacrificed their lives in completing the discovery of the North-West Passage A.D. 1847–8.' On the front of the pedestal is a bas-relief showing the burial of Franklin. On the back on a panel of embossed bronze is a chart of the

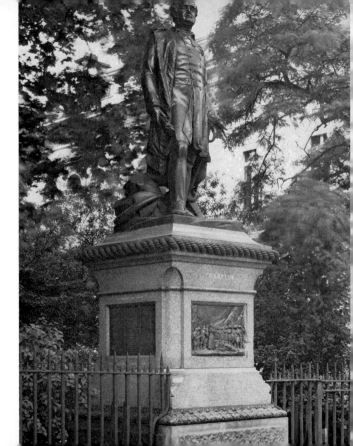

Arctic regions which shows the position of the ships at the time of Franklin's death. On the sides are bronze panels giving names of officers and crews.

John Franklin was born at Spilsby, Lincolnshire, on 16th April 1786 and educated at Louth Grammar School. He became a midshipman in the Navy and served at Copenhagen and at Trafalgar. He took part in three Arctic expeditions and was knighted when he returned from the third in 1829. From 1837 to 1843 he was Lieutenant-Governor of Van Diemen's Land and did much to help convicts there. In May 1845 he set out on his last expedition, from which he did not return. He and his crew in the *Erebus* and *Terror* attempted to discover a north-west passage through the Arctic seas. The ships were last sighted at the entrance of Lancaster Sound in July 1845. Many relief expeditions were sent to search for the missing men but little was discovered until Sir Leopold McClintock came upon boats, skeletons and a record stating that Franklin had died on 11th June 1847, and that the rest under Crozier had left the ships in April 1848 after nineteen months in the ice. There were no survivors. Franklin has since been recognized as the discoverer of the North-West Passage.

For sculptor see page 40.

Frere, Sir Bartle, 1st Baronet 1815–84.

Victoria Embankment Gardens.
Sculptor Sir Thomas Brock.
Unveiled 5th June 1888.

A bronze statue on a pedestal of light grey granite. Sir Bartle is shown standing, bareheaded, in Civil Service uniform and with an open flowing robe of the Order of the Star of India. The pedestal bears the shields of India and Africa and an allegorical figure in high relief on the front.

Henry Bartle Edward Frere was born at Clydach, Brecon, on 29th March 1815. Educated at Bath and Haileybury, he entered the Bombay Civil Service in 1834. He was concerned with the relief of the Punjab during the Mutiny and was Governor of Bombay, 1862–7. In 1872 he was sent to Zanzibar to negotiate the suppression of the slave trade. He accompanied the Prince of Wales to India in 1875 and was created a Baronet in 1876. Subsequently he became Governor of the Cape and the first High-Commissioner of South Africa. His policy was held to have partly caused the Zulu war and he was recalled to England, where he defended himself in his writings. He died on 29th May 1884 and was buried in St Paul's Cathedral.

For sculptor see page 96.

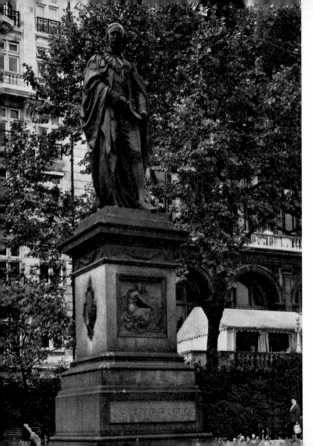

George II, King 1683–1760 (p. 50).

Golden Square, Soho.
Sculptor John Van Nost.
Erected 1753.

A statue in Portland stone representing the King in
Roman costume. It is said to have come from
Canons, near Edgware, the seat of the Duke of
Chandos which was pulled down in 1747.

George Augustus, only son of George I, was born on
10th November 1683 in Hanover, where he lived with
his grandparents after his parents were divorced.
He married Caroline of Brandenburg-Anspach in 1705
and came to London in 1714 and was created Prince
of Wales. When he succeeded his father in 1727 he
became King of Hanover as well as of Great Britain.
He is chiefly distinguished as the last English king
to have led his troops into battle personally, at the
battle of Dettingen in 1743. He died at Kensington
Palace on 25th October 1760 and was buried in
Westminster Abbey.

Another statue of King George II stands in the
courtyard of the Royal Naval College at Greenwich.

John Van Nost (or Ost), an inhabitant of Mechelen,

49

came to England and worked for Quellin, later taking over his yard. He did carving for royal palaces and great houses. He died in 1729.

George III, King 1738–1820 (p. 51).

Cockspur Street, Pall Mall.
Sculptor Matthew Cotes Wyatt.
Unveiled 3rd August 1836.

A bronze equestrian statue showing the King in military uniform, holding his hat in his right hand.

George III, son of Frederick, Prince of Wales, and grandson of George II, was born in London on June 4th 1738. He became King in 1760 and in 1761 married Charlotte Sophia of Mecklenburg-Strelitz. His long reign was not a happy one; in his youth he was encouraged to break away from the growing tendency towards constitutional monarchy, which had made great strides under his Hanoverian predecessors, and to take a direct part in running the country. He bears a share of the responsibility for estranging the American colonies and his blindness and mental illness later in life presented great constitutional difficulties, requiring a regency from 1811. Nevertheless he was respected and his personal

popularity somewhat redeemed his reign, which included the Napoleonic War. He died on 29th January 1820.

A more elaborate statue is to be found in the courtyard of Somerset House in the Strand. The work of John Bacon the elder, it was erected in 1808 and consists of an equestrian statue of the King in Roman costume as part of a fountain group.

Matthew Cotes Wyatt was born in 1777. The son of an architect, he early obtained work on the ceilings of Windsor Castle because of his father's position as Surveyor-General. He became a favourite of the royal family, and produced statues for several royal, as well as lesser stately, homes. He was the sculptor of the controversial statue of the Duke of Wellington which was designed for the top of Decimus Burton's arch at Hyde Park Corner. He died in 1862.

George IV, King 1762–1830 (p. 52).

Trafalgar Square.

Sculptor Sir Francis Chantrey.

A bronze equestrian statue of the King who is bareheaded and holding a baton in his right hand. The horse has no stirrups and is shown, most unusually, at rest. The statue was originally designed

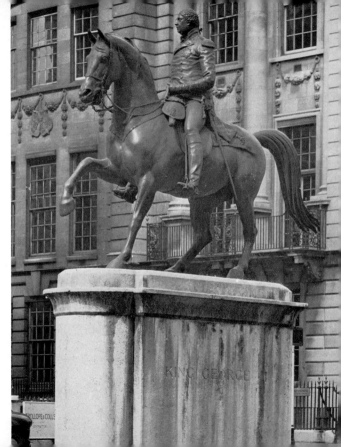

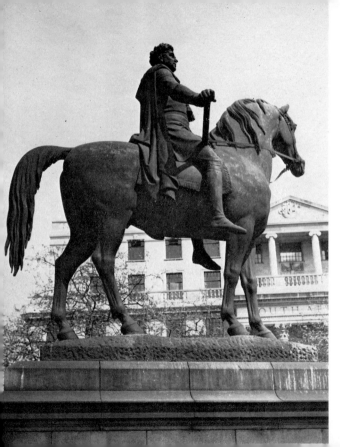

to be placed on top of the Marble Arch (now at the Oxford Street corner of Hyde Park). It was begun in 1829 but was not placed on its present site until 1843.

George, the eldest son of George III and Queen Charlotte, was born on 12th August 1762 at St James's Palace. He was well educated but brought up in strict seclusion with his brother at Kew. He was one of the most disliked of British kings. A morganatic marriage (with Mrs Fitzherbert), his disreputable and unconcealed private life and his irresponsible interference in politics embarrassed his country. In 1795 he married Princess Caroline of Brunswick but they soon separated. Appointed Prince Regent in 1811 when his father became insane, he was a poor figurehead for the country's pride after its success in the long-drawn-out Napoleonic War. He died on 26th June 1830.

Sir Francis Legatt Chantrey, R.A., was born in 1781. From poor beginnings he became a wood-carver and then turned to painting. Self-taught, he later exhibited at the Royal Academy and became the fashionable sculptor of his age. He died in 1841, leaving his large fortune to the Royal Academy to found the Chantrey Bequest.

George V, King 1865–1936.

Old Palace Yard, Westminster.
Sculptor Sir W. Reid Dick.
Architect Sir Giles Gilbert Scott.
Unveiled 22nd October 1947.

A stone statue on a tall stone plinth. The King is shown standing erect, bareheaded, wearing uniform and decorations. His hands are clasped before him on the hilt of the Sword of State. A long cloak hangs from his shoulders and falls in large folds to the rear. The plinth is inscribed with his name and the dates of his reign.

George Frederick Ernest Albert, second son of Edward VII, was born at Marlborough House, London, on 3rd June 1865. He trained at Greenwich for a naval career, but relinquished this on becoming heir apparent on the death of his brother in 1892. The following year he was made Duke of York and married Princess Victoria Mary of Teck. Soon after he became King on 6th May 1910 he was faced with a constitutional crisis which he met with dignity. Shortly afterwards came the Irish Home Rule tension, soon followed by the outbreak of World War I. George V was regarded with unusually strong affection by his people, whose outburst of spontaneous joy at his Silver Jubilee in 1935 is said

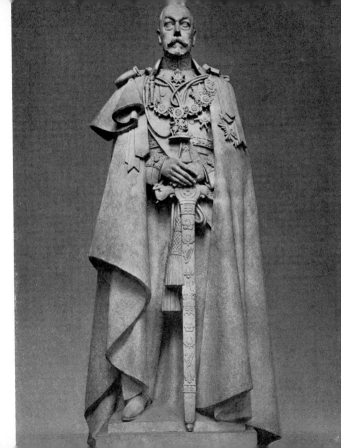

to have surprised him. He died at Sandringham on 20th January 1936.

Sir William Reid Dick, K.C.V.O., R.A., Hon. R.S.A., F.R.B.S., was born in Glasgow in 1879. He exhibited at the Royal Academy from 1908 and was President of the Royal Society of British Sculptors. He died in 1962.

George VI, King 1895–1952.

The Mall.
Sculptor W. McMillan.
Unveiled 21st October 1955.

The statue, on Carlton House Terrace overlooking the Mall, is of bronze on a stone pedestal. The King is standing, bareheaded, in the uniform of an Admiral of the Fleet, wearing decorations and the Order of the Garter. His left hand is resting on his sword and he is wearing a long cloak. The pedestal is inscribed with his name.

Albert Frederick Arthur George, second son of George V, was born at Sandringham on 14th December 1895 and educated at the Royal Naval College, Osborne, and Trinity College, Cambridge. He was created Duke of York in 1920 and married Lady Elizabeth Bowes-Lyon (now the Queen Mother),

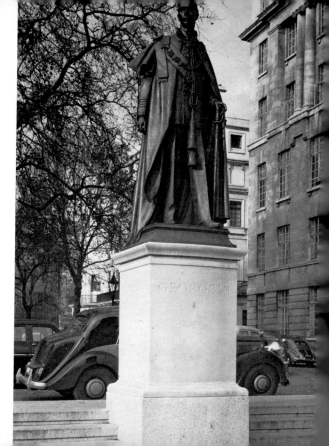

daughter of the Earl of Strathmore, in 1923. On the abdication of his brother, Edward VIII, he succeeded to the throne in 1936 and was widely respected and loved for the quiet and conscientious way he went about his royal duties in peace and in war, despite his natural diffidence. He was the first reigning British sovereign to visit America. During World War II he remained in London through the bombing, in which Buckingham Palace was damaged, and later visited troops abroad in both Europe and North Africa. He died at Sandringham on 6th February 1952.

William McMillan, R.A., a Scottish sculptor born in Aberdeen in 1887, designed the 1914–18 War Medal and also the Victory Medal.

Gladstone, William Ewart 1809–98.

Strand, Aldwych.

Sculptor Sir (William) Hamo Thornycroft.

Unveiled 4th November 1905.

A large bronze statue on a pedestal of Portland stone. The statesman is shown standing erect and wearing the robes of the Chancellor of the Exchequer. At the base of the column but above the plinth are four bronze groups representing Brotherhood, Education, Aspiration and Courage. On bronze panels between

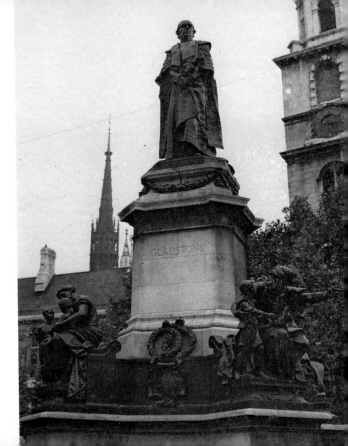

the groups are decorated escutcheons bearing the arms of some of the places which Gladstone represented in Parliament.

William Ewart Gladstone, the son of Sir John Gladstone, was born in Liverpool on 29th December 1809 and educated at Eton and Christ Church, Oxford. He entered Parliament as a Tory in 1833 but changed sides and became Liberal Leader in 1865. He had the unique distinction of being Prime Minister four times but his later career was clouded by the failure of his campaign for Home Rule for Ireland. Nevertheless his influence and standing in the country were enormous and he was universally known as the 'Grand Old Man' of British politics. A man of considerable moral stature and energy, his speeches were perhaps the most effective of his age; his writings, largely theological and ecclesiastical, are now little read. He died at Hawarden on 19th May 1898 and was buried in Westminster Abbey.

For sculptor see page 38.

Another very large statue stands in a churchyard in Bow Road, Tower Hamlets. Erected in 1882, it is of bronze on a red granite pedestal, the sculptor being Albert Bruce-Joy.

Gordon, General 1833–85.

Victoria Embankment Gardens.
Sculptor Sir (William) Hamo Thornycroft.

The statue was unveiled on 6th October 1888 and stood for many years in Trafalgar Square.

A statue of bronze on a pedestal of Derbyshire limestone, showing the General standing, deep in thought, his chin resting on his right hand, his left hand holding a Bible, with a cane under his arm. He is wearing the undress uniform of a Field Officer. On two sides of the pedestal are bronze panels, one representing Faith and Fortitude and the other Charity and Justice.

Charles George Gordon was born at Woolwich on 28th January 1833. He entered the Royal Engineers in 1852, served in the Crimean War and then made a national reputation for himself by his actions in the China Expedition of 1860. As 'Chinese Gordon' he was one of the most famous men of his time and was given wide powers in the Egyptian Sudan, of which he became Governor in 1877. In 1884 he had the task of withdrawing British garrisons in the face of the revolt of the Sudanese under the Mahdi, but was surrounded in Khartoum which was besieged for ten months. The fall of that city, in which he was killed on 26th January 1885, within a few days of probable

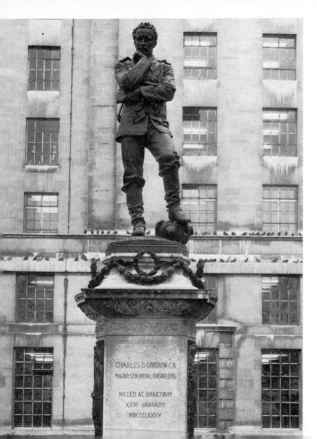

CHARLES G GORDON C.B.
MAJOR-GEN ROYAL ENGINEERS

KILLED AT KHARTOVM
XXVI JANVARY
MDCCCLXXXV

relief, caught the imagination of the people and caused a great outcry. There are a number of other memorials to him in various parts of the country and institutions were founded in Khartoum in his memory.

For sculptor see page 38.

Guy, Thomas 1645–1724 (p. 58).

Guy's Hospital.
Sculptor Peter Scheemakers.
Erected *circa* 1734.

A bronze statue on a stone pedestal. Guy is shown standing, in livery gown, with a scroll in his right hand. The front of the pedestal has the inscription: 'Thomas Guy, sole founder of this Hospital in his life time A.D. MDCCXXI.' The sides carry bas-reliefs representing the Good Samaritan, Christ healing the sick, and Guy's armorial bearings.

Thomas Guy was born in Southwark and educated at Tamworth. In 1668 he became a member of the Stationers' Company and set up as a bookseller in the City of London. He imported Dutch type and became one of the Oxford University Printers. He was Member of Parliament for Tamworth from 1695 to 1707. Guy made a fortune by dealing in

57

South Sea stock and built and endowed the London hospital which is named after him and which was originally intended to receive incurables and the insane. Christ's Hospital also received his benefactions and he erected almshouses and a town hall at Tamworth. He died on 27th December 1724.

For sculptor see page 42.

Haig, 1st Earl 1861–1928.

Whitehall.
Sculptor Alfred Frank Hardiman.
Erected 1937.

A bronze equestrian statue on a stone pedestal. The Earl is shown wearing uniform and a greatcoat and is bareheaded. He is holding a scroll in his right hand. The pedestal is decorated with his coat of arms and is inscribed: 'Field Marshal Earl Haig Commander-in-Chief of the British Armies in France 1915–1918.'

Douglas Haig was born in Edinburgh on 19th June 1861 and educated at Clifton, Oxford and Sandhurst. He joined the 7th Hussars and served in the Sudan, South Africa and India. He became Lieutenant-General in 1910 and took over the Aldershot command in 1912. When war broke out in 1914 he led the 1st Army Corps to France, conducted an orderly retreat after the battle of Mons, and showed skill and courage at the first battle of Ypres. In 1915 he was appointed Commander-in-Chief of the British Armies in France and Flanders and directed all the major battles of the war: the Somme, Arras, Passchendaele and the 1918 retreats. He led the armies to victory in 1918 and was created Earl in 1919. After the war he devoted himself to the cause of British ex-servicemen and

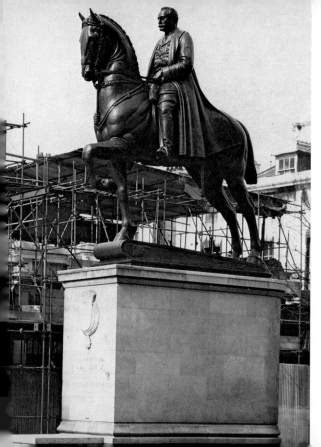

became President of the British Legion. He died on 29th January 1928 and was buried in Dryburgh Abbey.

Alfred Frank Hardiman, R.A., R.S., F.R.B.S., was born in 1891 and died in 1949.

Havelock, Sir Henry, 1st Baronet 1795–1857 (p. 60).

Trafalgar Square.
Sculptor William Behnes.
Erected 1861.

A bronze statue on a pedestal of Dartmoor granite. This military figure balances that of another hero of the Indian wars, Sir Charles Napier, and shows the soldier with his left hand on his sword and his cloak hanging behind him. Beneath the dedication is the inscription: '"Soldiers! Your labours, your privations, your sufferings and your valour will not be forgotten by a grateful country." H. Havelock.'

Henry Havelock was born at Bishop-Wearmouth, near Sunderland, on 5th April 1795 and educated at Charterhouse. He studied at the Middle Temple and then entered the Army in 1815. He served in the Burmese, Afghan, Mahratta and Sikh wars as well as the Persian Expedition. During the Indian Mutiny

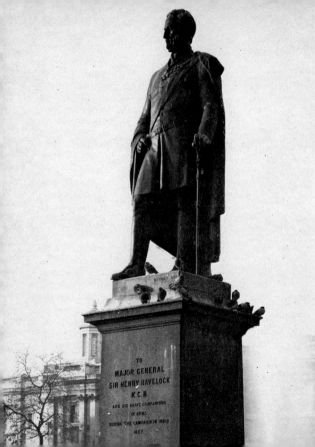

he commanded a column which recaptured Cawnpore, after winning four victories and marching 120 miles in nine days. Havelock was promoted to Major-General and with Sir James Outram was beseiged in Lucknow after breaking into that city. On 24th November 1857, only a week after being relieved by Sir Colin Campbell, he died of fever.

William Behnes was born of a Hanoverian father in London in 1795 and joined the Royal Academy Schools. He became a good and successful sculptor but fell into financial difficulties and died in poverty in 1864. His statue of Havelock is said to be the first modelled from a photograph.

Herbert, 1st Baron 1810–61.

Waterloo Place.
Sculptor J. H. Foley.

Unveiled 1st June 1867. Originally in front of the old War Office building in Pall Mall, it was removed to the new War Office and then to its present position in 1915.

A bronze statue on a carved granite pedestal. Lord Herbert is shown in Peer's robes, standing with head downcast, his face partially supported by his right hand, the elbow resting on the left hand which

holds a roll of papers. The pedestal has bronze bas-reliefs on three sides depicting: Florence Nightingale at the Herbert Hospital; volunteers on the march; the casting and testing of the first Armstrong gun at Woolwich. On the fourth side are the armorial bearings of his family. The monument balances that of Florence Nightingale in the group commemorating the Crimean War.

Sidney Herbert, the second son of the 11th Earl of Pembroke, was born at Richmond, Surrey, on 16th September 1810. He was educated at Harrow and Oriel College, Oxford. He entered Parliament as Member for South Wiltshire, remaining in office until shortly before his death. He served as War Secretary under three Prime Ministers and was largely responsible for Florence Nightingale being allowed to go to the Crimea. He led a movement in favour of medical reform in the Army and for the education of officers. In 1860 he was raised to the peerage as 1st Baron Herbert of Lea. His health was worn down by his endeavours and he died on 2nd August 1861.

J. H. Foley, R.A., was born in Dublin in 1818 and died in London in 1874. He had two brothers who were also well-known sculptors.

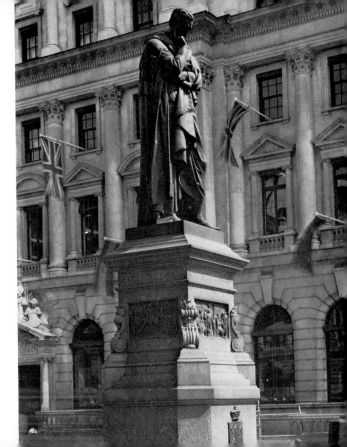

Hill, Sir Rowland 1795–1879.

King Edward Street.
Sculptor E. Onslow Ford.
Unveiled 17th June 1882.

A bronze statue on a pedestal of Dalbeattie granite. Hill is shown standing, bareheaded, with a notebook and pencil in his hand. The pedestal bears the inscription: 'He founded the Penny Postage, 1840.' The monument was originally placed by the Royal Exchange but now stands in front of the General Post Office.

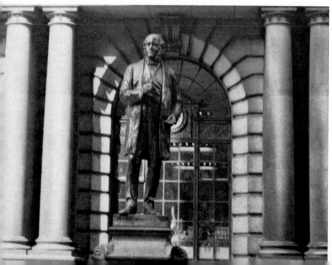

Rowland Hill was the son of a schoolmaster and was born at Kidderminster on 3rd December 1795 and educated at Birmingham. He taught in his father's school and became interested in the problems of teaching and administration. Although he had a wide range of interests he is remembered chiefly as the originator of the penny postage system, which he managed to put into effect in 1840, in spite of opposition, and from which developed the modern postal service. Hill became Secretary to the Postmaster-General, an appointment which became Secretary to the Post Office in 1854. He was awarded the K.C.B. in 1860. He died at Hampstead on 27th August 1879 and was buried in Westminster Abbey.

E. Onslow Ford, R.A., was born in London in 1852 and died in 1901. He was probably the best known sculptor of his time, especially valued for his life-like busts, of which he produced more than sixty.

Hogg, Quintin 1845–1903.

Langham Place.
Sculptor Sir George Frampton.

Unveiled 24th November 1906. The two side inscriptions were added later.

62

A bronze statuary group on a stone pedestal. Hogg is shown seated, reading a book to two boys. One of the boys is seated on his right, the other looking over Hogg's left shoulder. There are three inscriptions on the pedestal: 'Quintin Hogg. 1845–1903. Erected by the members of the Polytechnic to the memory of their Founder'; '1845–1918. Alice A. Hogg, whose unfailing love and devotion contributed to the success of the Polytechnic'; '1914–1918. Pro Patria. To the members of the Polytechnic who made the great sacrifice.'

Quintin Hogg, the son of Sir James Weir Hogg, was born in Grosvenor Street, Mayfair, on 14th February 1845 and educated at Eton. He became a partner in a firm of sugar merchants. Interested in philanthropic work with boys, he started a school near Charing Cross. He purchased the Royal Polytechnic Institution, Regent Street, in 1882 and opened it for 'athletic, intellectual, spiritual and social recreation'. Its success led to the spread of the polytechnic movement in London. He died on 17th January 1903.

For sculptor see page 30.

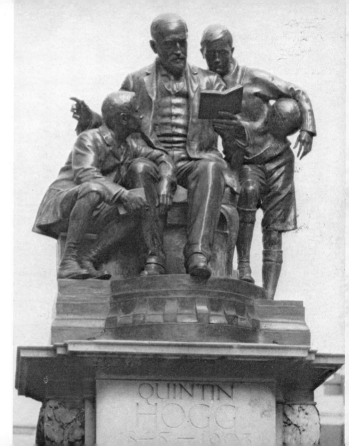

63

Huskisson, William 1770–1830.

Pimlico Gardens, Grosvenor Road.
Sculptor John Gibson.

Erected in about 1836, it was moved to its present position in 1915.
A marble statue and pedestal. Huskisson is shown standing, wearing a toga and holding a scroll in his right hand. The pedestal bears his name and dates of birth and death. The statue originally stood in the Royal Exchange.

William Huskisson was born at Birchmonton Court, Worcestershire, on 11th March 1770. He was educated privately in Paris, where he became private secretary to the British Ambassador. He entered Parliament as Member for Morpeth and a number of ministerial posts followed. After he was appointed Treasurer of the Navy and President of the Board of Trade in 1823 he introduced a number of reforms in various trades, notably those of silk, cotton and woollen goods, glass, paper and other commodities. He was attacked for his free trade tendencies but recognized as an authority on economic affairs. He became Colonial Secretary and Leader of the House of Commons.
 Huskisson was killed by being run over by an engine at the opening of the Manchester–Liverpool railway on 15th September 1830.

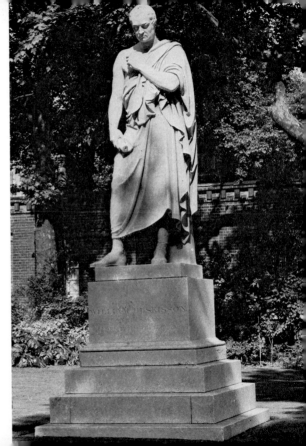

John Gibson, R.A., lived much of his life in Italy but most of his work is in England. He experimented in polychromy (the tinting of sculpture in the Graeco-Roman manner). He received many commissions from Queen Victoria. He was born near Conway in 1790 and died in Rome in 1866. He was granted the French Legion of Honour and left most of his fortune to the Royal Academy.

Irving, Sir Henry 1838–1905.

Charing Cross Road, south entrance.
Sculptor Sir Thomas Brock.
Unveiled 5th December 1910.

A bronze statue on a granite pedestal. The actor is shown standing, bareheaded, wearing the gown of a Doctor of Literature. He holds a manuscript in his left hand and his right hand rests on his hip. There is an inscription: 'Erected by English actors and actresses and by others connected with the theatre in this country.' His name, dates and honours are also given.

65

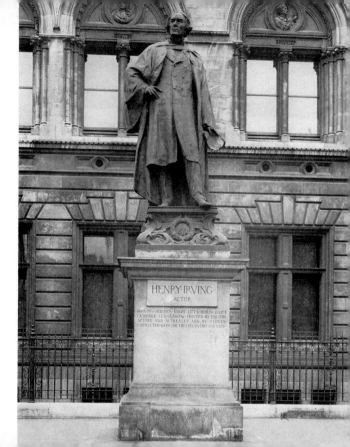

Henry Irving was the professional name of John Henry Brodribb and he was born at Keinton-Manderville in Somerset on 6th February 1838. He was at first employed as a clerk in the City of London but decided to become an actor and made his first appearance at the Lyceum Theatre in Sunderland. For ten years he played in provincial stock companies and first became famous as Matthias in *The Bells* at the London Lyceum in 1871. He scored a further triumph as Hamlet, the first of many Shakespearean rôles which revived popular interest in Shakespeare. In 1878 Irving became the lessee and manager of the Lyceum and began an association with the actress Ellen Terry which lasted until 1902. He made many tours of America and was the first actor to be knighted. He died in Bradford on 13th October 1905 after playing in Tennyson's *Becket* earlier in the evening.

For sculptor see page 96.

James II, King 1633–1701.
Trafalgar Square.
Sculptor Grinling Gibbons.

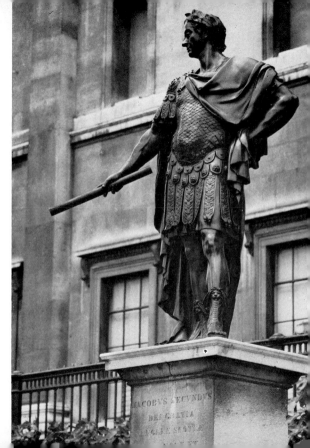

A bronze statue on a stone pedestal. The King is shown in Roman costume, holding a baton in his right hand. There is a Latin inscription on the pedestal which, translated, says: 'James II, by the Grace of God, King of England, Scotland, France and Ireland, Defender of the Faith A.D. 1686.' The statue was originally placed behind the Banqueting Hall of Whitehall Palace. In 1897 it was removed to the garden of Gwydyr House, and to St James's Park in 1903. It now stands outside the National Gallery. It is a companion statue to that of Charles II at Chelsea Hospital.

James was the second son of Charles I and was born at St James's Palace on 14th October 1633. He was made Duke of York in 1643. He escaped to the Continent during the Civil War and served in the armies of both France and Spain. At the Restoration he returned to England and was made Lord High Admiral and Lord Warden of the Cinque Ports. He married Anne Hyde, daughter of the Earl of Clarendon, in 1660. She died in 1671 and he contracted a second marriage to Mary of Modena. James became a Roman Catholic and favoured an alliance with France; both attitudes made him unpopular and when in 1685 he succeeded his brother Charles II as King his standing in the country was low. He suppressed the rising under the Duke of Monmouth in 1685 but was overthrown by the invasion of William of Orange in 1688: 'The Glorious Revolution'. He spent the last ten years of his life in exile at the court of St Germains in France, devoting himself to religion. He died on 6th September 1701.

For sculptor see page 32.

Jenner, Edward 1749–1823 (p. 68).

Kensington Gardens.
Sculptor W. Calder Marshall.

A bronze statue on a pedestal of Portland stone with panels of Aberdeen granite. Jenner is shown seated, holding papers in his right hand and with his chin resting on his left hand. The statue originally stood in Trafalgar Square where it was unveiled on 17th May 1858. It was removed to its present site in 1862.

Edward Jenner was born at Berkeley, Gloucestershire, on 17th May 1749. After studying in London under anatomist John Hunter he began to practise in Berkeley. He experimented to discover a cure for the scourge of smallpox and to this end first vaccinated with cow-pox in 1796. After a parliamentary inquiry

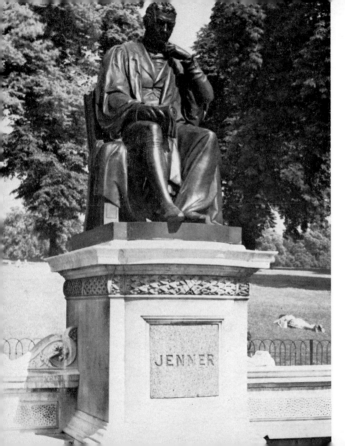

he received grants and in 1808 the National Vaccine Establishment was founded. Jenner died at Berkeley in 1823. It was not until 1853 that vaccination was made compulsory in England.

William Calder Marshall was born in 1813 and died in 1894. One of the most prolific of Victorian sculptors, he was born in Edinburgh and studied at the Royal Academy Schools and in Rome. He is known for his poetic and imaginative work.

Johnson, Dr Samuel 1709–84.

St Clement Danes, Strand.
Sculptor Percy Fitzgerald.
Unveiled 5th August 1910.

The statue is of bronze on a pedestal of Belgian marble with bronze decorations. Doctor Johnson is standing with an open book in his left hand and other books at his feet. His right arm is raised and he is wearing a full-bottomed wig. The pedestal bears a medallion of James Boswell, his biographer, on the front and scenes from Johnson's life on the sides. The inscription says: 'Samuel Johnson, LL.D., Critic, Essayist, Philologist, Biographer, Wit, Poet, Moralist, Dramatist, Political Writer, Talker.' Samuel Johnson was the son of a bookseller and was

68

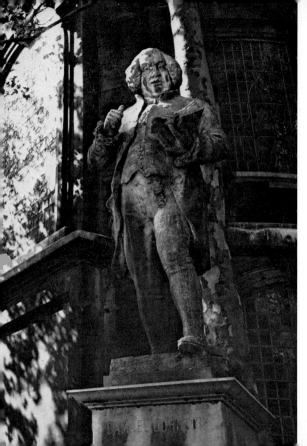

born in Lichfield in 1709. He went to grammar school there and then to Pembroke College, Oxford, but took no degree. In 1735 he married Elizabeth Porter, a widow much older than himself. The marriage was a happy one. In 1737 he came to London, accompanied by David Garrick who was one of his pupils. His literary career began with contributions of essays, poems, and political reports to the *Gentleman's Magazine*. From 1747 to 1755 he was mainly engaged in compiling his *Dictionary of the English Language* and producing *The Rambler* periodical. He wrote the famous letter to Lord Chesterfield which virtually destroyed the dependence of the writer on patronage. Known as the Great Cham of Literature, he founded the 'Literary Club', whose members included Reynolds, Burke, Goldsmith, Garrick, Fox and Boswell. Later works include his edition of Shakespeare and *The Lives of the Poets*. Johnson died in 1784 at his house in Bolt Court and was buried in Westminster Abbey.

Percy Fitzgerald, F.S.A., a devoted Johnsonian who edited an edition of Boswell's *Life of Johnson*, was both sculptor and donor of the statue, which he also unveiled. The original unveiling was to have been made by Princess Louise, Duchess of Argyll, but this was cancelled because of the death of King Edward VII.

69

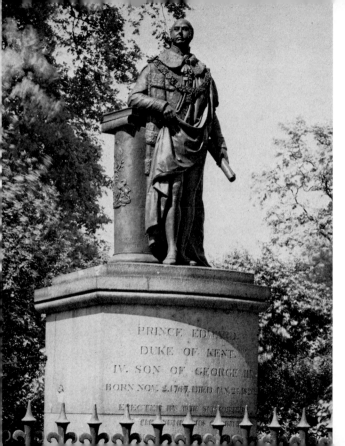

Kent, Duke of 1767–1820.

Portland Place.
Sculptor S. Gahagan.
Erected between 1820 and 1827.

A bronze statue on a pedestal of unpolished granite. The Duke is shown standing, in Field Marshal's uniform and Peer's robes. His right arm is resting on a book on a short column and there is a roll of papers in his left hand. There is an inscription on the pedestal giving his name and dates of birth and death and saying: 'Erected by the supporters of the numerous charities which he so zealously and successfully patronized.'

Edward Augustus, Duke of Kent and Strathern, was born on 2nd November 1767. He was the fourth son of George III and Queen Charlotte and was educated in England under John Fisher and also in Germany and Switzerland. He entered the Army and served in Gibraltar, Canada and the West Indies, becoming a Field Marshal by 1805. He was an unpopular officer but was nevertheless the first to abandon flogging in the Army and to establish a regimental school. In 1818 he married Victoria Mary Louisa, widow of the Duke of Saxe-Saalfeld-Coburg. In 1819 they had a daughter, Victoria, who became Queen Victoria. He died on 23rd January 1820.

Sebastian Gahagan, the best known of this large family of sculptors, came to London from Dublin and became assistant to Nollekens. He is one of the most eminent of British sculptors and exhibited at the Royal Academy from 1802 to 1835.

Kitchener, 1st Earl 1850–1916.

Horse Guards Parade.
Sculptor John Tweed.
Unveiled 9th June 1926.

A bronze statue on a pedestal of Portland stone in front of a screen of the same stone which is set into a wall. The wall backs on to No. 10 Downing Street. Kitchener is shown standing bareheaded and wearing the service uniform of a Field Marshal. His hands are crossed. The inscription says 'Kitchener 1850–1916'.

Horatio Herbert Kitchener was of English Protestant stock and was born near Listowel, County Kerry, Ireland, on 24th June 1850. He was educated privately and at the Royal Military Academy, Woolwich. He received a commission in the Royal Engineers and carried out surveys in Palestine and Cyprus before serving in the Sudan where he was made Sirdar (commander) of the Egyptian Army.

He commanded the Army in the defeat of the Mahdi at Omdurman in 1898 and was afterwards made Governor-General of the Sudan. He went to South Africa to serve as Chief of Staff to Lord Roberts in the Boer War and was created a Viscount. He became Commander-in-Chief, India, in 1902, Field Marshal in 1909 and Consul-General in Egypt in 1910. In 1914 he became Secretary of State for War, being responsible not only for strategy but also for raising 'Kitchener's Armies'. Sent on a mission to Russia in H.M.S. *Hampshire*, he went down with her when she struck a mine off the Orkneys on 5th June 1916.

For sculptor see page 118.

Lawrence, John, 1st Baron 1811–79.

Waterloo Place.
Sculptor Sir Joseph Edgar Boehm.
Unveiled 1882.

A bronze statue on a granite pedestal. The Baron is shown standing bareheaded, with his left hand resting on his sword and holding a small paper in his right hand. The inscription says: 'Ruler of the Punjaub during the Sepoy Mutiny of 1857. Viceroy of India from 1864 to 1869'.

72

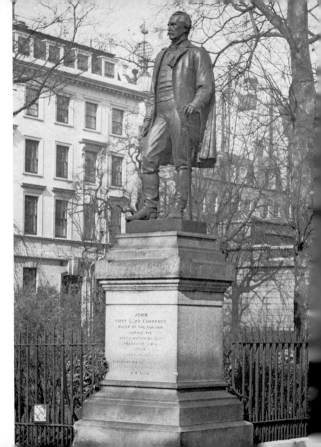

John Laird Mair Lawrence was born at Richmond, Yorkshire, on 4th March 1811. He was educated at Bristol, Londonderry, Bath and Haileybury and was employed by the East India Company in Calcutta and Delhi. He was Chief Commissioner for the Punjab during the Indian Mutiny and it was due to his advice and action that Delhi was recaptured. Lawrence was created a Baronet in 1858 and was Viceroy of India, 1864–9. During this time he was much concerned with improvements and reforms in sanitation, irrigation and railways, and with establishing peace. He was created Baron Lawrence of the Punjab and of Grately in 1869 and served as Chairman of the London School Board, 1870–3. He died on 27th June 1879 and was buried in Westminster Abbey.

There are two statues of Lawrence by Boehm. The first was erected in Lahore.

For sculptor see page 23.

Lawson, Sir Wilfrid 1829–1906.
Victoria Embankment Gardens.
Sculptor David McGill.
Erected 20th July 1909.

A bronze statue on a pedestal of stone. Lawson is

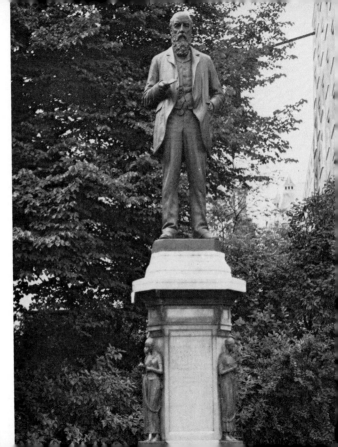

shown standing, bareheaded, with notes in his right hand and his left hand in his coat pocket. The inscription gives his name, dates of birth and death and of offices he held. Also the words: 'A true patriot, a wise orator, a valiant and farseeing reformer; he spent a long life as the joyous champion of righteousness, peace, freedom, temperance.' Around the base of the pedestal are bronze figures representing Temperance, Peace, Fortitude and Charity.

Wilfrid Lawson was the son of Sir Wilfrid Lawson and was born at Carlisle on 4th September 1829. He was privately educated and entered Parliament as Member for Carlisle. As a temperance advocate, he supported a motion for the Sunday closing of public houses in 1863. He succeeded to the baronetcy in 1867. Lawson was a supporter of religious freedom, strongly denounced the South African war, and defended free trade. He was also a keen sportsman and a writer of light verse. He died on 1st July 1906.

David McGill lived in London and exhibited at the Royal Academy from 1889 to 1904.

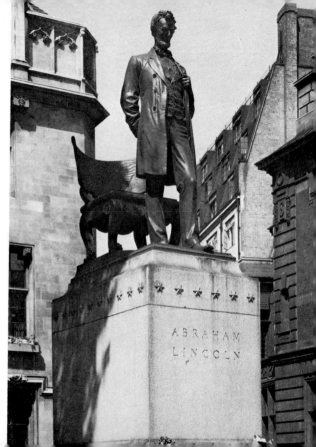

Lincoln, Abraham 1809–65.

Parliament Square.
Sculptor Augustus Saint-Gaudens.
Unveiled 1920.

A bronze statue on a stone pedestal. The President is shown standing in front of an elaborate chair which has the design of an eagle on the curved back. He is bareheaded, with his left hand grasping the lapel of his frock coat and his right hand held behind him. The pedestal bears his name and is decorated with thirty-two stars. The monument is a replica of the one in Lincoln Park, Chicago.

Abraham Lincoln was born on 12th February 1809 in a backwoods cabin in Kentucky. His family moved to Illinois in 1830 and he followed various occupations and then studied law. By the time he began to be prominent in national politics Lincoln had become one of the most successful lawyers in Illinois. In 1842 he married Mary Todd and in 1860 he was elected as the first Republican president. He laboured for the abolition of slavery, a policy which caused the secession of the Southern States and the Civil War, which lasted four years. The Northern States prevailed and slavery was abolished.

Lincoln was shot by a fanatic as he sat in Ford's Theatre, Washington, on 14th April 1865. He died early the following morning.

Augustus Saint-Gaudens was born in Dublin in 1848 and died in 1907. He was taken to the United States as a child. His work was much influenced by French artists and he is known for his heroic sculpture.

McGrigor, Sir James, 1st Baronet 1771–1858(p. 76).

Royal Army Medical College, Millbank.
Sculptor Matthew Noble.
Erected 18th November 1865 in the grounds of Chelsea Hospital. Removed to its present position in 1909.

A bronze statue on a pedestal of polished Scotch granite. Sir James is shown standing erect, bareheaded, in uniform, with a long cloak hanging from his shoulders and holding a scroll in his right hand. The inscriptions on the pedestal give his name, medical and other degrees and awards, dates of birth and death, a list of the countries in which he served and a quotation from one of Wellington's dispatches, dated 26th July 1814: '"One of the most industrious, able and sacrificing public servants I have met."'

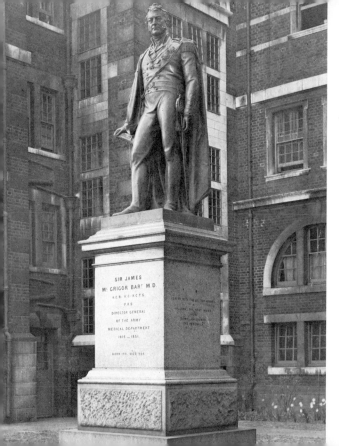

James McGrigor was born at Cromdale, Inverness-shire, on 9th April 1771. He was educated at Aberdeen Grammar School and Marischal College and studied medicine at Aberdeen and Edinburgh universities. He became an Army surgeon and served in Flanders, the West Indies and India. He was made Inspector General of Hospitals in 1809 and was chief of the medical staff of Wellington's army in the Peninsular in 1811. Following this he was Director-General of the Army medical department for many years. He was knighted in 1814, became a Baronet in 1830 and was awarded a K.C.B. in 1850. He died in London on 2nd April 1858.

For sculptor see page 40.

Mill, John Stuart 1806–73.

Victoria Embankment Gardens.
Sculptor Thomas Woolner.
Erected 26th January 1878.

A bronze statue on a pedestal of Portland stone. Mill is shown seated, leaning forward, with his right hand holding a book and his left hand resting on his knee. The carved pedestal is inscribed with his name.

John Stuart Mill was born at Rodney Street, Pentonville, on 20th May 1806. He was the eldest son of philosopher James Mill and was educated by his father, studying advanced subjects at an early age. He was employed by the East India Company from 1823 until its dissolution in 1858. During these years he published a number of philosophical works. He formed the Utilitarian Society but later departed from Bentham's doctrine. Among his many works *System of Logic* (1843) and *Principles of Political Economy* (1848) are perhaps the best known. He was Member of Parliament for Westminster from 1865 to 1868, after which he lived mainly in France, returning to London for only very short periods. He died in Avignon on 8th May 1873.

Thomas Woolner, R.A., was born in Suffolk in 1825 and studied under Behnes and Rossetti. He produced a large number of portraits and busts of eminent Victorians. He was appointed Royal Academy Professor of Sculpture in 1877 but resigned in 1879. He died in 1892.

Millais, Sir John 1829–96 (p. 78).
Tate Gallery, Millbank.
Sculptor Sir Thomas Brock.
Erected 1905.

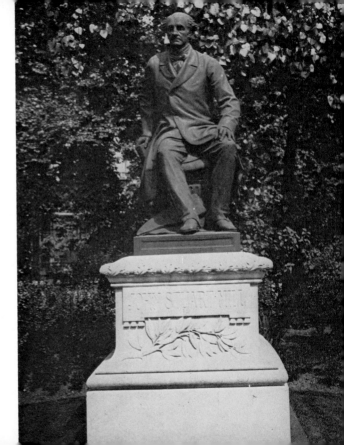

The statue is of bronze on a pedestal of Portland stone. The artist is standing, bareheaded, holding a palette in one hand and a brush in the other. His name is inscribed on the pedestal.

John Everett Millais was born in Southampton on 8th June 1829. He studied in Bloomsbury and later entered the Royal Academy Schools where he gained every prize for which he competed. He first exhibited in the Royal Academy in 1846. He was one of the founder members of the Pre-Raphaelite Brotherhood, together with Holman Hunt and Dante Gabriel Rossetti. Their ideas and techniques had a considerable influence on the arts and fashions of the time. In 1853 he became a member of the Royal Academy and in 1855 married Euphemia Chalmers Grey, who had obtained a decree of nullity of her marriage to John Ruskin. In some of his later paintings Millais moved away from the Pre-Raphaelite style. He was made a Baronet in 1885, the first artist to be given this honour, and succeeded Lord Leighton as President of the Royal Academy in 1896. He died the same year and was buried in St Paul's Cathedral.

For sculptor see page 96.

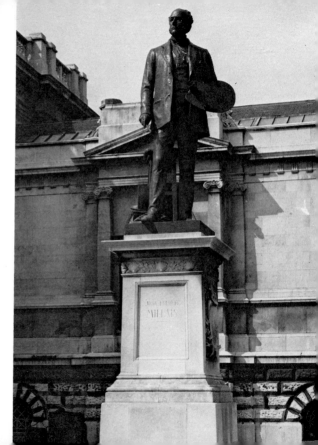

More, Sir Thomas 1478–1535.

Chelsea Embankment.
Sculptor L. Cubitt Bevis.
Unveiled 21st July 1969.

A bronze statue on a low stone pedestal. More is
shown seated, wearing Chancellor's robes and hat.
His hands are clasped before him and a chain with
the Tudor Rose emblem is laid across his knees.
His signature is reproduced on the bronze platform
at the base.

Thomas More, son of judge Sir John More, was born
on 7th February 1478, educated at St Anthony's
School, Threadneedle Street, London, and
Canterbury Hall, Oxford. He studied at New Inn
and Lincoln's Inn, becoming brilliantly successful at
the Bar and devoting his leisure to literature. His
most important work, *Utopia*, was published in 1516.
He became a member of Henry VIII's court, being
an intimate of the King, and held several high offices
until he succeeded Wolsey as Lord Chancellor in
1529. He resigned in 1532, having incurred Henry's
disfavour for opposing the relaxation of the heresy
laws and refusing to act for the King's divorce from
Queen Catherine. He was committed to the Tower,
indicted of high treason and executed on 6th July 1535.

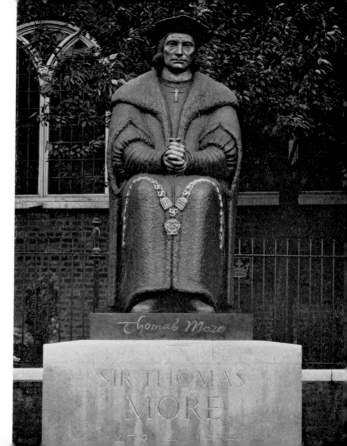

In 1935, four hundred years after his death, he was canonized by the Pope.

L. Cubitt Bevis was born in Maidstone in 1892. After distinguished service in World War I he became an art master and subsequently Vice-Principal of Wakefield School of Art. He set up his studio in Paris in 1934 but from 1939 was again involved in war, becoming a senior officer in the field of camouflage. He has worked and exhibited paintings and sculptures in many countries, including at the Royal Academy and the Paris salons.

Napier, Sir Charles 1782–1853.

Trafalgar Square.
Sculptor G. G. Adams.
Unveiled 1856.

A bronze statue, on a granite pedestal, which balances a similar figure of another hero of the Indian War, Sir Henry Havelock. The General is shown standing, bareheaded, in undress uniform. He is holding his sword in his left hand and in his right hand he holds a scroll, symbolic of the constitution granted to Sind under his governorship. The pedestal is inscribed with his name and dates of birth and death.

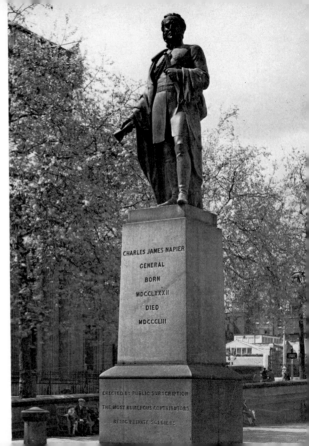

Charles James Napier, the son of Colonel George Napier, was born in London on 10th August 1782. In 1794 he entered the Army, serving in the Irish rebellion of 1798. He was taken prisoner during the retreat from Corunna under Sir John Moore in 1809 but returned to Portugal and served throughout the Peninsular Campaign. His victory in the Sind War led to the annexation of that province, of which he was appointed Governor in 1843. He was Commander-in-Chief, India, 1849–50 and died near Portsmouth on 29th August 1853.

George Gammon Adams was born in Staines in 1821 and died in Chiswick in 1898. He attended the Royal Academy Schools and later studied in Rome. As a medallist he designed and cut a number of medals, including the prize ones of the Great Exhibition of 1851.

Napier of Magdala, 1st Baron 1810–90.

Queen's Gate.

Sculptor Sir Joseph Edgar Boehm.

Unveiled 8th July 1891 at its original site at Waterloo Place where the statue of King Edward VII now stands. It was removed to its present position in 1920.

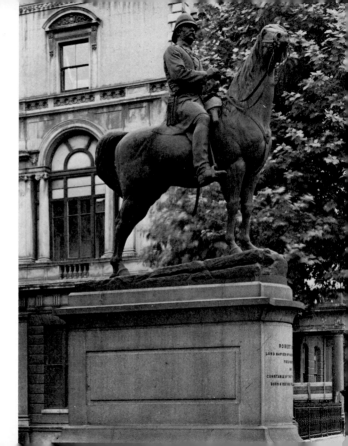

A bronze equestrian statue on a pedestal of granite. Napier is shown in uniform and wearing a helmet. The inscription says: 'Robert Napier, Lord Napier of Magdala G.C.B., G.C.S.I., Field Marshal and Constable of the Tower of London.' It also gives his dates of birth and death. The statue is a replica of that erected in Calcutta. It was unfinished when the sculptor died and the work that remained was superintended by Alfred Gilbert.

Robert Cornelis Napier was born at Colombo, Ceylon, on 6th December 1810. He received a commission in the Bengal Engineers and gave distinguished service in the Sikh wars. His skill in engineering led to his appointment as Civil Engineer of the Punjab in 1849; more successes followed in India and China. His greatest achievement was his command of the Abyssinian Expedition of 1867 when he attacked Magdala. He was created Baron Napier of Magdala the following year, became Commander-in-Chief, India, in 1870, Governor of Gibraltar in 1876 and Field Marshal in 1883. He died on 14th January 1890.

For sculptor see page 23.

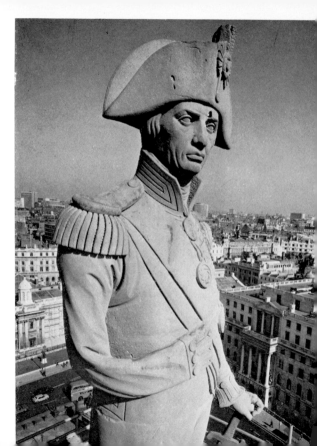

Nelson, Horatio, Viscount 1758–1805.

Trafalgar Square.

Monument designed by William Railton.

 Sculptors

 Statue—E. H. Baily.

 Lions—Sir Edwin Landseer.

 Bas-reliefs (under the superintendence of
 C. L. Eastlake and Sir Richard Westmacott)—M. L.
 Watson (St Vincent), W. F. Woodington (Aboukir),
 J. Termouth (Copenhagen), J. E. Carew (Trafalgar).

A granite Corinthian column on a pedestal of grey granite surmounted by a stone statue of Nelson. He is shown wearing full dress uniform of the Royal Navy. The statue is 17 feet high; the total height of the monument is $170\frac{1}{2}$ feet. At the base of the column are four bronze lions each 20 feet long and 11 feet high. There are four bronze bas-reliefs on the side of the pedestal, cast from the metal of captured French cannon. They represent incidents in the battles of St Vincent, Aboukir, Copenhagen and Trafalgar. The capital is of bronze cast from cannon recovered from the deck of the Royal George. The monument was begun in 1840 but was not completed until 1867.

Horatio Nelson was born at Burnham Thorpe in Norfolk on 29th September 1758. He entered the Navy in 1770, serving in the West Indies and becoming a Commander in 1778. In 1793 he sailed in the *Agamemnon* for the Mediterranean to join Lord Hood and met Sir William and Lady Hamilton for the first time. He took part in the capture of Bastia and Calvi in Corsica, here losing the sight of his right eye. For his share in the battle of Cape St Vincent in 1797 against the combined French and Spanish fleets he was knighted and became to Rear-Admiral. In the same year he lost his right arm when attempting to capture a treasure ship at Santa Cruz. After destroying the French fleet in Aboukir Bay in 1798 he was created Baron Nelson of the Nile. In 1801 he was sent to command an attack at Copenhagen. Victorious again, he was made a Viscount on his return. Nelson's greatest victory, however, was off Cape Trafalgar on 21st October 1805. He died there on his flagship *Victory* and his body was brought to England and buried in St Paul's Cathedral. He was posthumously created an Earl.

Edward Hodges Baily, R.A., was born in Bristol in 1788, began to model in wax and then became a pupil of Flaxman. He designed for goldsmiths for many years and produced sculpture for the Marble Arch and for the façade of the National Gallery. He died in 1867.

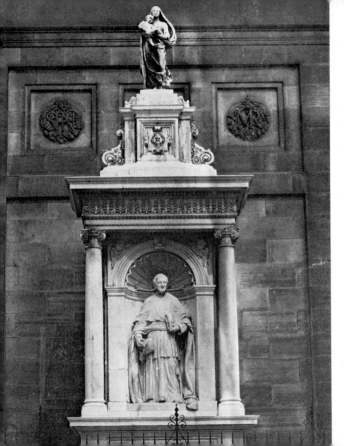

Newman, Cardinal 1801–90.

Brompton Oratory.
Sculptor Chavalliaud.
Unveiled 15th July 1896.

A white marble statue on a pedestal of brown
Portland stone, standing within a pillared shrine.
The Cardinal is shown in ecclesiastical robes, a book
in his left hand and his Cardinal's hat in his right.
The inscription on the base of the pedestal says
'John Henry Cardinal Newman 1801–90'. There are
armorial bearings on the sides of the pedestal and a
stone screen in the rear. The monument is surmounted
by figures of the Virgin and the infant Christ.

John Henry Newman was born in London on 21st
February 1801. He was educated at Ealing and
Trinity College, Oxford, later becoming a Fellow and
a Tutor of Oriel, and was appointed Vicar of
St Mary's, Oxford, in 1828. After travelling in
southern Europe he began publication of *Tracts for
the Times* which formed the foundation for the
Tractarian or Oxford Movement. He resigned the
living of St Mary's and two years later, when visiting
Rome, was received into the Roman Church. On his
return he established the Oratories at Birmingham
and London. Newman published various writings on
the Catholic Church. In 1879 he was created Cardinal

84

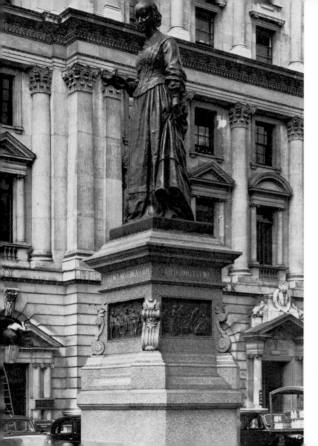

of St George in Velabro. He died in Birmingham on 11th August 1890.

Leon Joseph Chavalliaud was a French sculptor who was born in Reims in 1858 and died in 1921. He was in London from 1893 to 1904.

Nightingale, Florence 1820–1910.

Waterloo Place.
Sculptor Arthur George Walker.
Erected 1915.

A bronze statue on a pedestal of polished red granite on a grey granite base. Miss Nightingale is shown in her nurse's uniform and carrying her lamp. The square pedestal has four bas-reliefs representing: a conference of nurses; the visiting of a hospital; the transporting of wounded soldiers; and an interview with military authorities.

Florence Nightingale, the daughter of wealthy parents, was born on 12th May 1820 in Florence and named after the city of her birth. She was educated at home and had to struggle against strong opposition from her family when she decided to make nursing her

career. She underwent courses of training at Kaiserworth in Germany and in Paris. It was not until 1853 that she was able to take up her first post, running a small hospital in Harley Street, London. This she did so successfully that it led Sidney Herbert, Secretary of War, to invite her to undertake a mission to the Crimea. She sailed with a company of thirty-eight nurses and reached Scutari in November 1854. The conditions of the barracks hospital were appalling and by enormous efforts she brought order out of chaos. The wounded called her 'The Lady with the Lamp'. Miss Nightingale also visited other hospitals in Balaclava and introduced sanitary reforms. When she returned to England in 1856 a large sum of money raised by public subscription was placed at her disposal and with it she founded a training school for nurses at St Thomas's Hospital. She retired from active nursing but continued to work hard for the improvement of nursing and hospitals, military and civil, for sanitary reforms and public health. For her work she received many awards including the Order of Merit.

She died on 3rd August 1910. By her wish a national funeral and burial at Westminster Abbey was refused and she was buried in her family grave at East Wellow in Hampshire.

Arthur George Walker, R.A., was born in 1861. He studied at the Royal Academy Schools, was a prolific sculptor and did much work for churches. He died in 1939.

Outram, Sir James, 1st Baronet 1803–63.

Victoria Embankment Gardens.
Sculptor Matthew Noble.
Unveiled 17th August 1871.

A bronze statue on a pedestal of polished granite. The General is shown standing, in uniform, with some rockwork, a helmet and a mortar behind him. There are groups of Indian arms and trophies at the corners of the pedestal.

James Outram was the son of Benjamin Outram, civil engineer. He was born at Butterley Hall, Derbyshire, on 29th January 1803 and educated at Marischal College, Aberdeen. He entered the Indian Army and was successful in a series of military campaigns. He also performed great hunting exploits. In Afghan disguise he carried dispatches from Kalat back to India and was described by Napier as the 'Bayard of India'. When the Indian Mutiny broke out

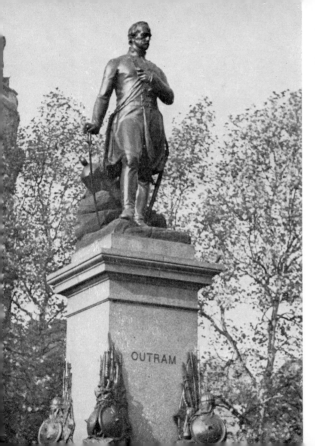

OUTRAM

he was Chief Commissioner of Oudh and in charge of two Bengal divisions, but he waived his military rank and served under Havelock at the siege of Lucknow. He became Lieutenant-General in 1858 and received a baronetcy and the Freedom of the City of London. He died at Pau on 11th March 1863 and was buried in Westminster Abbey.

For sculptor see page 40.

Palmerston, 3rd Viscount 1784–1865 (p. 88).

Parliament Square.

Sculptor Thomas Woolner.

The statue is of bronze. The pedestal of grey granite was designed by E. M. Barry. Palmerston is shown standing with a mantle thrown over the right arm, the left hand slightly extended. Two models were set up in Parliament Square in 1869 and 1874 before the actual statue was erected and unveiled on 2nd February 1876.

Henry John Temple, the elder son of the 2nd Viscount Palmerston, was born at Broadlands, Romsey, Hampshire, on 20th October 1784 and was educated at Harrow, Edinburgh and St John's College, Cambridge. He succeeded to the Irish peerage in 1802, was elected Tory Member of Parliament for

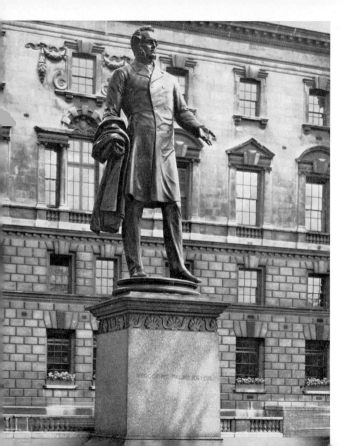

the Isle of Wight in 1807 and became successively Lord of the Admiralty, Secretary for War and Foreign Secretary. As Foreign Secretary he obtained independence for Belgium and was greatly concerned with and largely successful in affairs involving Greece, Portugal, Spain and Turkey. Palmerston served three terms as Prime Minister. He died on 18th October 1865 at Brocket Hall in Hertfordshire and was buried in Westminster Abbey.

For sculptor see page 77.

Pankhurst, Emmeline 1858–1928.

Victoria Tower Gardens.
Sculptor Arthur George Walker.
Unveiled 6th March 1930.

A bronze statue on a stone pedestal. Mrs Pankhurst is shown standing, bareheaded, wearing a long coat with a fur collar and holding a lorgnette in her left hand. The inscription is on the flagstone at the base of the pedestal and says: 'This statue of Emmeline Pankhurst was erected as a tribute to her courageous leadership of the movement for the enfranchisement of women.' The smaller pedestals, at each side of the monument, bearing bronze plaques to Dame Christabel Pankhurst and to the Women's Social and

Political Union, were added later. There are inscriptions on the outer sides of these pedestals.

Emmeline Goulden, the daughter of Robert Goulden, a calico printer, was born at Manchester on 14th July 1858. She attended finishing school in Paris and in 1879 married Richard Marsden Pankhurst, a Manchester barrister who had drafted the first Suffrage Bill. When her husband died in 1898 Mrs Pankhurst became Registrar of Births and Deaths at Rusholme in Manchester. She devoted herself to the cause of women's suffrage and in 1903 with her eldest daughter Christabel founded the Women's Social and Political Union. The suffragettes adopted sensational methods of propaganda and used violence. Mrs Pankhurst was constantly arrested and released again after hunger striking. At the outbreak of war she abandoned the suffrage campaign. In 1918 the right to vote was given to a limited number of women. Mrs Pankhurst lived in Canada and the United States of America from 1919 to 1925 but returned to England in 1926 and became a Member of Parliament in London.

She died in London on 14th June 1928, a month before the Act was passed which gave women full equality in the franchise.

For sculptor see page 86.

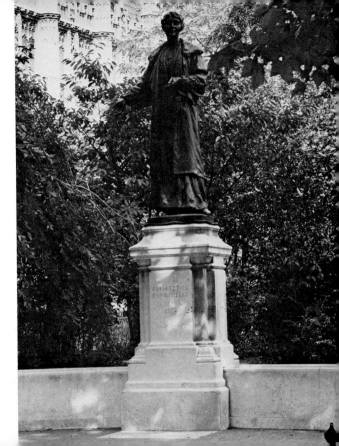

Peabody, George 1795–1869.

Royal Exchange.
Sculptor W. W. Story.
Unveiled 1869.

A bronze statue on a polished red granite pedestal.
Peabody is shown bareheaded and seated in a chair.

George Foster Peabody was born in Danvers,
Massachusetts, U.S.A. He made a fortune in dry
goods and came to England in 1827, settling in
London and setting up in business as a merchant
and a banker. He founded the 'Peabody Dwellings'
for housing the working classes in various parts of
London, his gifts to the London poor amounting to
over half a million pounds. Peabody was also a
benefactor of Harvard and Yale universities,
establishing a museum of archaeology and ethnology
at Harvard and a natural history museum at Yale.
He refused a baronetcy and a G.C.B.

He died on 4th November 1869 in London; his
body was taken to the United States in a British
warship and was buried at Danvers, since renamed
Peabody. In 1940 there were established in his
memory radio and television awards for outstanding
services by broadcasters.

William Witmore Story was an American born in
1819. He had a varied career and was a writer, but

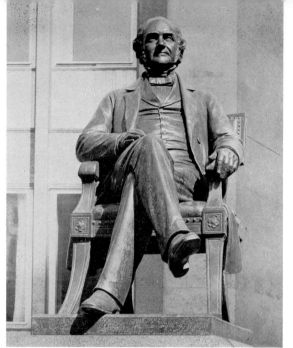

took up sculpture seriously in 1847. He settled in
Rome, where his literary friends included Robert
Browning. He died in 1895.

Peel, Sir Robert, 2nd Baronet 1788–1850.

Parliament Square.

Sculptor Matthew Noble.

Erected 1876.

A bronze statue on a pedestal of polished red granite.
Peel is shown standing, bareheaded and as if speaking
in the House of Commons. This is the third statue
to have been made. The original by Marochetti was
objected to as being too large for the site. Marochetti
made a smaller one at his own expense and it was
erected in New Palace Yard in 1868 but was later
melted down and used to make the present statue.

Robert Peel, born on 5th February 1788 near Bury,
Lancashire, was the eldest son of the 1st Baronet.
He was educated at Harrow and Christ Church,
Oxford, and became Tory Member of Parliament for
Cashel, Ireland. Appointed Chief Secretary for
Ireland, he successfully opposed Catholic emancipa-
tion. He established the 'peace preservation police'
who were popularly known as Bobbies and Peelers.
They formed the beginning of our modern police
force. Peel held a number of offices, including Home
Secretary, Leader of the House of Commons and
Chancellor of the Exchequer. He worked to build
what became the Conservative Party and in 1841
was appointed Prime Minister. The main achieve-

91

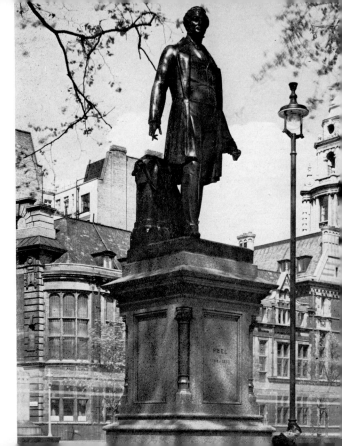

ment of his administration was the repeal of the Corn
Laws which he succeeded in getting through the House
of Lords; on the same day, however, he was defeated
in the Commons over the Irish question and resigned.
He continued to take an active part in political
affairs but held no further office. He died on 2nd July
1850 as the result of falling from his horse on
Constitution Hill, Hyde Park Corner.

There is another bronze statue of Peel in Postman's
Park, Aldersgate.

For sculptor see page 40.

Peter, 2nd Count of Savoy 1203/13-68.

Courtyard of Savoy Hotel, Strand.
Sculptor Lynn Jenkins.
Erected 1904.

A bronze gilt statue which stands above the entrance
arcade of the Savoy Hotel. The Count is shown
standing with his right hand resting on his shield and
holding a lance and pennon in his left hand.

Peter of Savoy, the seventh son of Thomas I of
Savoy, was born at Susa sometime between 1203
and 1213. His niece, Eleanor of Provence, became

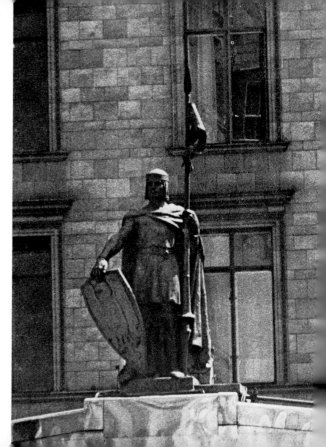

Queen to Henry III and the Count came to England in 1240 and was given the honours of Richmond. He held various offices in England and became a valued counsellor and ambassador to the King, who gave him the manor on the Thames which became known as the Savoy, and also the manor of Cheshunt in Hertfordshire. Unexpectedly succeeding as Count of Savoy in 1263, he left England to claim his inheritance and never returned, though he continued to help King Henry. He died at Pierre-Chatel on about 15th May 1268.

The Savoy Palace in London derived its name from him. Part of the Savoy Hotel now stands on the site of his manor.

Frank Lynn Jenkins was born in 1870 and lived for some years in New York. He won many prizes and was particularly well known for his decorative schemes for public buildings.

Pitt, William 1759–1806.
Hanover Square.
Sculptor Sir Francis Chantrey.
Unveiled 22nd August 1831.

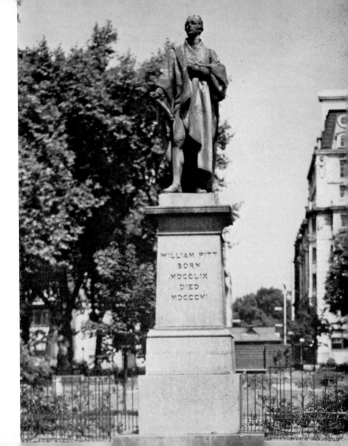

A bronze statue on a granite pedestal. Pitt is shown standing, wearing a large robe. The pedestal bears his name and dates of birth and death.

William Pitt was the second son of the 1st Earl of Chatham and was born at Hayes in Kent on 28th May 1759. He was educated at Pembroke Hall, Cambridge, called to the Bar at Lincoln's Inn and became Member of Parliament for Appleby in 1781. The following year he was made Chancellor of the Exchequer and in 1783 became Prime Minister at the age of twenty-four. This ministry failed but he obtained an overwhelming majority in 1784 and from then onwards, except for a brief interval, was Prime Minister for twenty years. For some years he was largely engaged with finance and attempts to make the country economically sound. He bore the burden of leading his country for the first thirteen years of the war with France, despite steadily declining health.

He died at his house in Putney on 23rd January 1806, soon after hearing of the defeat of his coalition at Austerlitz. His last words were: 'Oh my country! How I leave my country!'

For sculptor see page 52.

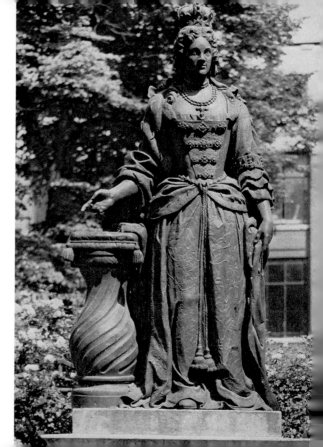

A Queen.

Queen Square, Bloomsbury.
Sculptor unknown.

A leaden statue, on a stone pedestal, of a crowned queen wearing a richly embroidered gown with a tasselled girdle round her waist. At one time a sceptre was awkwardly held in her right hand but it was probably a later addition to the original statue and has now been removed. The figure is standing beside a carved pillar upon which rests a cushion.

The statue was commonly thought to be of Queen Anne, after whom this square is named, and this belief was held throughout the nineteenth century. Newspapers of April 1775, however, report that 'the statue of Her Majesty was set up in Queen Square' and mention an inscription on the pedestal: 'Virtutis Decus et Tutamen.' The report presumably referred to Queen Charlotte, consort of George III, but the present statue shows no resemblance to portraits of her and there is no trace of any inscription on the pedestal. Other theories are that it may portray Queen Mary, wife of William III, or Queen Caroline, wife of George II.

Raikes, Robert 1735–1811.

Victoria Embankment Gardens.
Sculptor Sir Thomas Brock.
Unveiled 3rd July 1880.

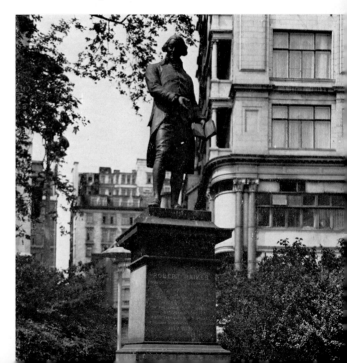

A bronze statue on a pedestal of Cornish grey granite. Raikes is shown standing, teaching from a book held in the left hand. The inscription says: 'Robert Raikes, Founder of Sunday Schools, 1780. This statue was erected under the direction of the Sunday School Union by contributions from teachers and scholars of Sunday Schools in Great Britain. July 1880.'

Robert Raikes was born at Gloucester on 14th September 1735. He became a printer there, succeeding his father as proprietor of the *Gloucester Journal*. In 1780 with the Reverend Thomas Stock he started his first Sunday School for the religious training of neglected children. The idea was not his own but under his care and endeavour the system spread throughout the country. He died on 5th April 1811.

Sir Thomas Brock was born in 1847 in Worcester and became one of the leading sculptors of the Victorian era. He is famous for his portrait busts; many of the most distinguished personages of the day sat for him. A large number of medals were struck from his work. He died in 1922.

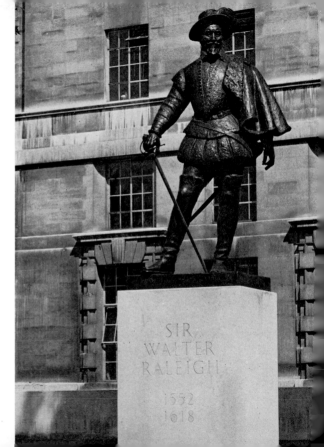

Raleigh, Sir Walter 1552–1618.

Whitehall.

Sculptor W. McMillan.

Unveiled 1959.

A bronze statue on a stone pedestal. Raleigh is shown standing, wearing Elizabethan costume, holding his sword in his right hand and with his cloak over his left shoulder. The pedestal is inscribed with his name and dates of birth and death.

Walter Raleigh was the son of a Devonshire gentleman of the same name and was born at Hayes Barton in South Devon, educated at Oriel College, Oxford, and served in France in the Huguenot army. After a 'voyage of discovery' and service in Ireland, he came to England and remained at court for several years, receiving bounties from Queen Elizabeth I which gave cause for scandal. He was knighted in 1584 and made further expeditions which resulted in settlements in Virginia. He married Elizabeth Throgmorton and, being forbidden the court, settled at Sherborne. He gave distinguished service at Cadiz and in the Azores but was imprisoned on a charge of treason in 1603 at the instigation of James I. He was kept in apartments in the Tower with his wife and son until 1616, being released to undertake a further expedition to the Orinoco in search of gold. Returning after the unfortunate burning of the Spanish settlement of San Thomé, for which he does not appear to have been responsible, he was arrested, imprisoned in the Tower and executed in Old Palace Yard, Westminster, on 29th October 1618.

For sculptor see page 55.

Reynolds, Sir Joshua 1723–92 (p. 98).

Burlington House, Piccadilly.

Sculptor Alfred Drury.

Unveiled 1931.

A bronze statue on a stone pedestal which stands in the forecourt of Burlington House. The painter is shown standing as if painting, with a brush in his right hand and a palette and more brushes in his left. The inscription on the pedestal gives his name, dates of birth and death and states that he was 'First President of the Royal Academy of Arts'.

Joshua Reynolds was born at Plympton, Devon, on 16th July 1723 and educated at the grammar school

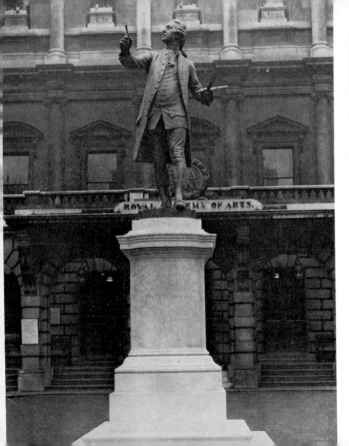

there, where his father was headmaster. He painted in Devon then travelled, visiting Italy, spending two years in Rome and being much influenced by Italian painting. In 1753 he settled in London where he lived for the rest of his life, first in St Martin's Lane and then in Leicester Square. He became very successful and did many portraits. In 1760 the Society of Artists was founded, followed by the Royal Academy of Arts in 1768, under the patronage of George III. Reynolds was elected President and knighted. From 1769 most of his important works appeared there. In later years he visited Flanders and Holland and was influenced by Rubens. He was a friend of such famous men of his day as Johnson, Goldsmith, Burke and Garrick. He died on 23rd February 1792.

Alfred Drury, R.A., was born in 1857, and studied in Oxford, London and under Dalau in Paris. He was a well-known sculptor whose numerous works include symbolic figures and portrait busts. In 1900 he was awarded a Gold Medal at the Paris Exhibition.

Richard I, King 1157–99.

Old Palace Yard, Westminster.

Sculptor Baron Carlo Marochetti.

Erected October 1860.

A bronze equestrian statue on a pedestal of granite with bronze bas-reliefs. The King is shown in chain-mail, crowned and with uplifted sword. The pedestal is inscribed with his name and dates of birth and death, and the bas-reliefs show Richard fighting the Saracens and Richard on his death bed. The inscription says 'Richard I, Cœur-de-Lion'. The statue is a bronze cast of the plaster model shown at the Exhibition of 1851.

Richard was the third son of Henry II and Eleanor of Poitou. He was born at Oxford on 8th September 1157, acknowledged Duke of Aquitaine in 1170 and became King of England in 1189. He was known as Cœur-de-Lion: The Lionheart. With Philip Augustus of Messina he set out on the Third Crusade in 1170 but they separated later, after a quarrel. Richard reached and conquered Cyprus in 1171 and married Berengaria of Navarre. He twice came within a few miles of Jerusalem but troubles in England necessitated his return and after arranging a truce with Saladin he turned back. When attempting to travel through Europe in disguise he was arrested near

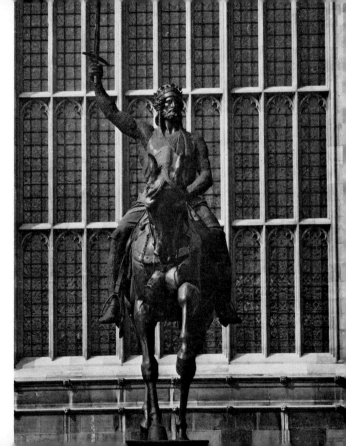

Vienna and imprisoned at Durnstein (where there is a fine modern statue of him). His English subjects paid a huge ransom and he arrived back in England in 1194. After two months he left to fight in France and restored the ducal authority in Aquitaine.

He died on 6th April 1199, mortally wounded by an arrow whilst besieging the castle of Chaluz. His body is buried at Fontrevault and his heart at Rouen. During the ten years of his reign he spent only six months in England.

For sculptor see page 22.

Roberts, Earl 1832–1914.
Horse Guards Parade.
Sculptor Harry Bates.
Unveiled 1924.

A bronze equestrian statue on a granite pedestal. The Earl is shown in uniform with sun helmet, posteen and Indian field-kit. The pedestal gives his

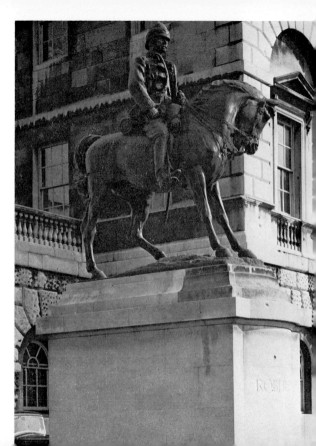

name, rank and decorations, and dates of birth, death and military appointments. The inscription concludes: 'Erected by Parliament in admiration of his illustrious military career and gratitude for his devoted service to the State.'

Frederick Sleigh Roberts, the younger son of General Sir Abraham Roberts, was born at Cawnpore, India, on 30th September 1832. He was educated at Eton, Sandhurst and Addiscombe. He entered the Bengal Artillery and served in the Indian Mutiny, being awarded the Victoria Cross in 1858. After serving in Abyssinia and the North West Frontier of India he became Commander of the Punjab Frontier Force in 1878. In the Afghan War he led the famous march from Kabul to Kandahar. In 1900 he took command of the British Army in the Boer War and at its end was created Earl. He was very popular with the troops and was celebrated by Kipling as 'Bobs'.

He died on a visit to the Indian units in France on 14th November 1914 and was buried in St Paul's Cathedral.

Harry Bates, A.R.A., was born in 1850 and died in 1899. He was a favourite sculptor of the Victorian era and also did another statue of Roberts for Calcutta.

Roosevelt, Franklin Delano 1882–1945 (p. 102).

Grosvenor Square.
Sculptor W. Reid Dick.
Unveiled 12th April 1948.

A bronze statue on a stone pedestal. The President is shown standing, bareheaded, and with his left hand clasping his lapel. His right hand is obviously holding his stick, but is hidden under his cloak.

Franklin Delano Roosevelt, the only son of wealthy parents, was born at Hyde Park, New York, on 30th January 1882. He was educated at Groton and Harvard and studied law at Columbia University. In 1905 he married Eleanor Roosevelt, a distant cousin, and in 1910 was elected to the New York Senate. In 1921 he was stricken with poliomyelitis, which he struggled to overcome with great courage and determination; but for the rest of his life he was partially crippled. He became the thirty-second President in 1932 and had the unique distinction of serving for four consecutive terms. In America he is known for the 'New Deal', proposed to help his country out of the slump era, but in this country he is held in affection for the friendship and support which he gave to Britain in her darkest hour in 1940. Roosevelt co-operated with Churchill and Stalin to exercise supreme command during the war but died

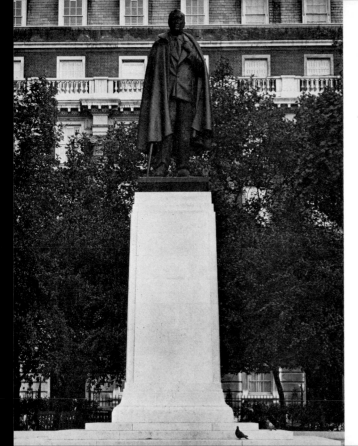

on 12th April 1945 at Warm Springs, Georgia, a few months before final victory.

For sculptor see page 54.

Scott, Captain Robert Falcon 1868–1912.

Waterloo Place.
Sculptor Lady Scott.
Unveiled 1915.

A bronze statue on a stone pedestal. The explorer is shown in arctic clothing, holding a skiing stick in his right hand. The inscription says that Scott 'with four companions E. H. Wilson, H. R. Bowers, L. E. G. Oates, E. Evans died March 1912, returning from the South Pole'. Beneath are words from the last entry in his diary: '"Had we lived I should have had a tale to tell of the hardihood and endurance and courage of my company which would have stirred the heart of every Englishman. These rough notes and our dead bodies must tell the tale."'

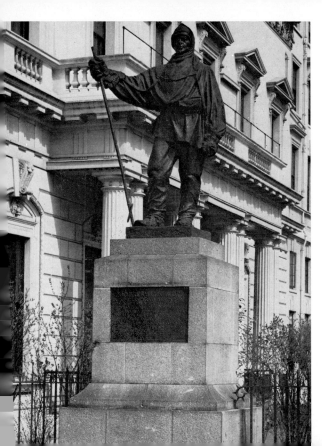

Robert Falcon Scott was born at Oatlands, Devonport, on 6th June 1868. He was educated for the Navy at Fareham, Hampshire, became a naval cadet in 1881 and by 1891 had achieved the rank of lieutenant. In 1900 he was chosen to lead the National Antarctic Expedition, in the *Discovery*. The expedition returned in 1904, having successfully investigated hitherto unknown areas of the Antarctic. Scott was made a captain and awarded the C.V.O. In 1910 he commanded a second expedition in an attempt to reach the South Pole. He sailed from New Zealand in the *Terra Nova* and, after a long journey by sledge, reached the Pole on 18th January 1912 to find that the Norwegian expedition under Roald Amundsen had preceded them. Scott and his four companions all perished on the return journey, beset by bad weather, sickness and lack of food. Eight months later a search party found the tent with the bodies of Scott, Wilson and Bowers, and Scott's records and diaries. The last entry in the diary was made on 29th March 1912. Scott was posthumously knighted.

Lady (Kathleen) Scott, A.R.B.S., daughter of Canon Lloyd Bruce, was the wife of Captain Scott. In 1922 she became Lady Kennet. She died in 1947.

103

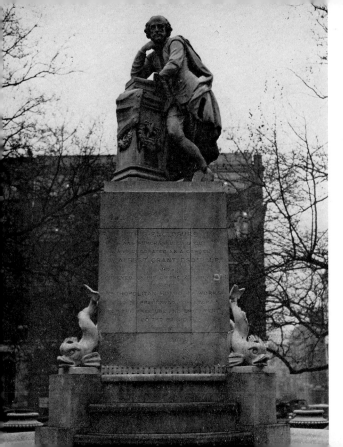

Shakespeare, William 1564–1616.

Leicester Square.
Sculptor Fontana, after Scheemakers.
Unveiled 2nd July 1874.

A fountain surmounted by a statue of white marble.
The poet is shown with his elbow leaning on three
books placed on a small column and with his right
hand pointing to the words: 'There is no darkness
but ignorance.' The figure is a reproduction of the
statue by Peter Scheemakers from the design of
William Kent in Westminster Abbey. The pedestal
and fountain basin, also of marble, were designed by
James Knowles.

William Shakespeare was the eldest son of John
Shakespeare and Mary, daughter of Robert Arden,
a farmer of Wilmcote. He was born at Stratford-on-
Avon on about 23rd April 1564 and baptized in the
parish church on 26th April. Very few facts are known
about his life. He may have attended grammar school
in Stratford. He certainly married Anne Hathaway
there in 1582, left for London in 1586 and by 1594
had become a member of the Lord Chamberlain's
Company of Players. It became the King's Company
in 1603 and Shakespeare performed with them at
several London theatres, including the famous Globe

and Blackfriars. He gained his early experience as a dramatist by revising and rewriting plays bought by the management. He returned to Stratford in 1611 and died there on 23rd April 1616 at his home New Place and was buried in Stratford Church. The first folio edition of his works was published in 1623.

There is another representation of Shakespeare on the Poets' Fountain in Park Lane, and also a bust in Aldermanbury.

Giovanni Fontana was born in Carrara in 1821 and died in London in 1893. He exhibited regularly, mainly portrait busts, from 1852 to 1886.
For Scheemakers see page 42.

Smith, Captain John 1579/80–1631.

Cheapside.

Sculptor William Couper.

A bronze statue on a stone plinth which stands in the square beside St Mary-le-Bow Church. The Captain is shown standing, in Elizabethan costume, his left hand on his sword, his right hand holding a Bible. An inscription on one side of the pedestal says: 'Captain John Smith, Citizen and Cordwainer 1580–1631. First among the Leaders of the

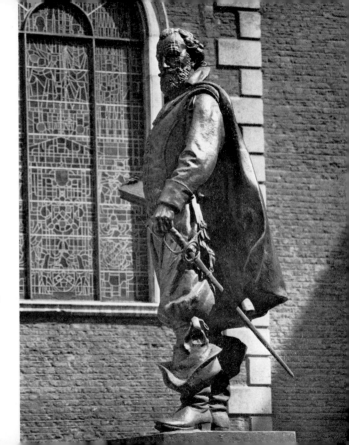

Settlement at Jamestown, Virginia, from which began the overseas expansion of the English Speaking Peoples.' On the other side of the pedestal are further details of the statue, which was unveiled on 31st October 1960 and which is a replica of that erected in 1907 in Jamestown, Virginia, U.S.A.

John Smith was born at Willoughby in Lincolnshire and baptized on 6th January 1579/80. From about sixteen years of age he led a life of travel and adventure and wrote about his experiences. He was enthusiastic about the setting up of colonies in America and went with the party that reached Virginia in 1607. When things went badly, owing to sickness and lack of provisions, Smith made difficult and dangerous expeditions to trade with the Indians for food, and always returned successful. It was on one of these journeys that his life was saved by the Indian Princess Pocahontas. In 1608 Smith explored Chesapeake Bay and travelled up the Potomac River as far as the site where Washington now stands. In 1614 he charted the coast of a country which he called New England, his map being surprisingly accurate. He made several more unsuccessful attempts to reach New England to create settlements and thereafter devoted himself to arousing interest in American colonization. He died in June 1631 and is buried in St Sepulchre, Newgate.

William Couper was born in Norfolk, Virginia, in 1853 and died in Maryland in 1942. He studied in Germany and Italy before settling in New York and becoming known for his idealized works of famous Americans.

Smuts, Field Marshal 1870–1950.
Parliament Square.
Sculptor Sir Jacob Epstein.
Unveiled 1956.

A bronze statue on a stone pedestal. The Field Marshal is shown standing and leaning forward, with his hands behind his back. He is in uniform and bareheaded.

Jan Christian Smuts was of Dutch origin and was born in Cape Colony, South Africa, on 24th May 1870. He was the son of Jacobus Abraham Smuts, a farmer and Member of the Cape Parliament. He was

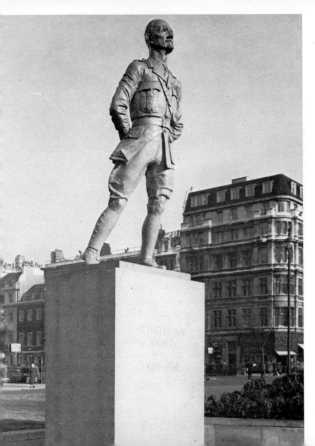

educated at Riebeeck West School, Victoria College, Stellenbosch and Christ's College, Cambridge. In 1895 he was admitted to the Cape Bar and married Sybella Margaretha Krige in 1897. When South Africa was declared a republic he became State Attorney and worked for peace in the growing tension with Britain. When war broke out he became one of the leaders of the Boer Army and a notable guerrilla fighter. When peace arrived he took an important part in the negotiations leading up to the formation of the Union of South Africa. On the outbreak of war in 1914 he became a Lieutenant-General in the British Army, commanding the forces in the East African Campaign. In 1917 he joined the British War Cabinet. Between the wars he was three times Prime Minister of South Africa and during World War II he became one of Churchill's most trusted advisers. He was appointed Field Marshal in 1941 and awarded the Order of Merit in 1947. He died on 11th September 1950 at Irene, near Pretoria.

Sir Jacob Epstein, K.B.E., Hon. LL.D., was born in 1880 in New York of Russian-Polish parentage. He became one of the best known artists of the century, his striking sculpture especially causing great controversy; much of it is to be seen in London. He died in 1959.

107

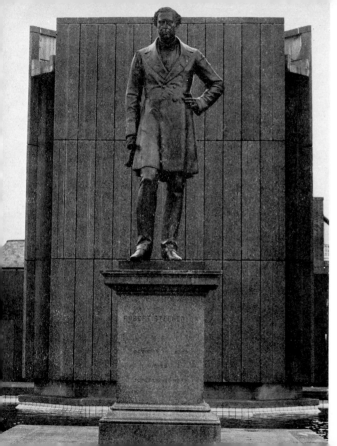

Stephenson, Robert 1803–59.

Euston Square.
Sculptor Baron Carlo Marochetti.
Erected 1871.

A bronze statue on a red granite pedestal. Stephenson is shown standing, wearing a frock-coat and holding a scroll in his right hand. His name is inscribed on the pedestal, with dates of birth and death.

Robert Stephenson was the son of George Stephenson, inventor of the locomotive. He was born near Newcastle and educated there and at Edinburgh University. For a time he was employed in a locomotive factory and also superintended mines in Columbia for several years. He took an important part in constructing the famous 'Rocket' locomotive for which his father won a prize. From 1833 to 1838 he constructed the London–Birmingham line. During the same period George Stephenson was engaged on constructing important lines in the North. Robert Stephenson later turned to bridge construction, notably the Menai tubular girder bridge and the Victoria bridge over the St Lawrence at Montreal. His reputation as a civil engineer became international and he received French, Belgian and Norwegian awards. He was President of the Institute of Civil Engineers, Fellow of the Royal Society and

Member of Parliament for Whitby from 1847 to 1859. He died on 12th October 1859 and was buried in Westminster Abbey.

For sculptor see page 22.

Trenchard, 1st Viscount 1873–1956.

Victoria Embankment Gardens.
Sculptor W. McMillan.
Erected 1961.

A bronze statue on a stone pedestal. The Viscount is shown standing, bareheaded, in uniform and wearing a greatcoat. His left hand is on his sword.

Hugh Montague Trenchard was born at Taunton, Somerset, on 3rd February 1873. He entered the Army in 1893 and served in the South African War and then in Nigeria. In 1912 he was invalided home. He took up flying the following year and became Assistant Commandant of the Central Flying School. During World War I he was Commander of the Royal Flying Corps and appointed 1st Chief of Air Staff in 1918. He married Mrs Katherine Boyle in 1920. In 1927 as 1st Marshal of the Royal Air Force he introduced training colleges and short service

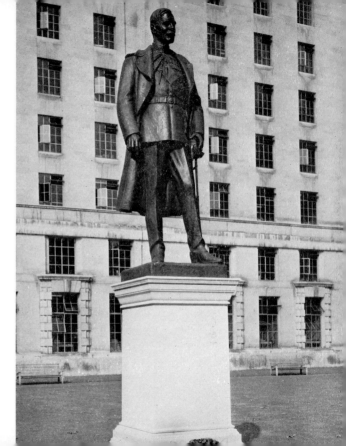

commissions. Trenchard embarked upon a third successful career in 1931 when he became Commissioner of Metropolitan Police, introducing reforms, short term service and scientific methods. He founded Hendon Police College which trained men from the ranks. He was created Baronet in 1919, Baron in 1930 and Viscount in 1936. From 1936 to 1953 he was Chairman of the United Africa Company. He died on 10th February 1956 in London.

For sculptor see page 55.

Tyndale, William 1484–1536.
Victoria Embankment Gardens.
Sculptor Sir Joseph Edgar Boehm.
Unveiled 7th May 1884.

A bronze statue on a pedestal of Portland stone. Tyndale is standing, robed, with his right hand upon an open copy of the New Testament which is resting on an early printing press. There are books and a scroll at his feet. The inscription on the front of the pedestal reads: 'First translator of the

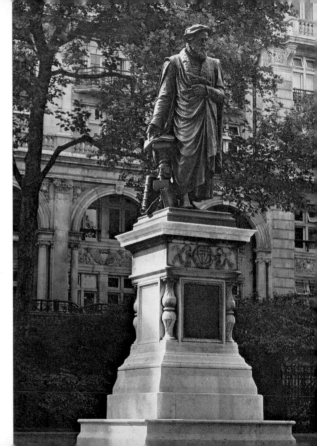

New Testament into English from the Greek. Born A.D. 1484. Died a Martyr at Vilvorde in Belgium A.D. 1536.' Then follow quotations from the Bible, and the inscription ends: 'The last words of William Tyndale were: "Lord. Open the King of England's eyes." Within a year afterwards a Bible was placed in every Parish Church by the King's Command.'

William Tyndale was born in Gloucestershire and educated at Oxford and Cambridge. He preached to introduce the New Learning and was involved in disputes with the clergy. He determined to translate the New Testament into English and went to Germany to try to accomplish this, visiting Martin Luther at Wittenburg. Printing of his translation was begun in Cologne and finished at Worms. When copies reached England they were denounced by the bishops and destroyed. He was ordered by Wolsey to be taken captive but found protectors on the Continent. He was engaged in further writing and translations for some years but was finally betrayed by his enemies, taken captive, tried, strangled and burned at the stake at Vilvorde in Belgium in 1536.

For sculptor see page 23.

Victoria, Queen 1819–1901 (p. 112).

Buckingham Palace.
Sculptor Sir Thomas Brock.
Monument designed by Sir Aston Webb.

The white marble statue shows the seated figure of the Queen, and backs on to a taller pillar on which is a gilded bronze figure of Victory. Around her are other symbolic figures. Indeed the whole podium is studded with figures representing abstract qualities, arts and industries. Around this again is a larger area set with flower beds, surrounded by a balustrade pierced by five exits and with more figures, shields and symbols. The monument is 82 feet high and was unveiled on 16th May 1911, although additions to it were made until 1924.

Alexandrina Victoria was born at Kensington Palace on 24th May 1819, the only child of Edward, Duke of Kent, fourth son of George III. Her early years were spent with her mother at Kensington Palace and she was privately educated there. She became Queen on 20th June 1837 in succession to her uncle, William IV, and in 1840 married Albert of Saxe-Coburg-Gotha, afterwards known as the Prince Consort. In 1876 she assumed the additional title of Empress of India. Her reign of sixty-three years was the longest of any British monarch. Many

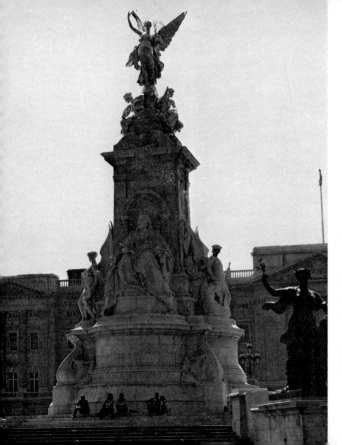

of her nine children and numerous grandchildren occupied European thrones. She died on 22nd January 1901 at Osborne, Isle of Wight.

There are many other memorials to Queen Victoria throughout London. Notable examples include the bronze statue (unveiled 21st July 1896) by C. B. Birch at the north end of Blackfriars Bridge, and the statue in Kensington Gardens: a seated figure of the Queen, at the time of her accession, by H.R.H. Princess Louise, Marchioness of Lorne, which was unveiled on 28th June 1893.

For sculptor see page 96.

Washington, George 1732–99.

Trafalgar Square, outside National Gallery.
Sculptor Jean Antoine Houdon.

A bronze statue on a low base of Portland stone. This is a replica of Houdon's marble statue at Richmond, Virginia, U.S.A. The President is shown standing, his right hand resting on his cane, his left hand on a fasces which is draped with a cloak and sword. He is bareheaded and in military dress. The inscription says: 'Presented to the people of Great Britain and Ireland by the Commonwealth of Virginia 1921.'

112

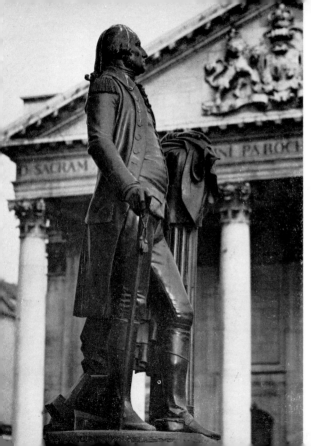

George Washington was born at Bridges Creek, Westmoreland County, Virginia, on 22nd February 1732. His father had been at school in England before managing his Virginia estates. The future President first worked as a surveyor, and at the age of twenty inherited estates which he managed enthusiastically. He accepted a military appointment and saw frontier action against the French. In 1759 he married Martha Dandridge, a rich widow. Supporting the movement against British mismanagement, he was appointed Commander-in-Chief of the military forces of Virginia and later of the new Republic. After the successful outcome of the war he became the first President of the United States, serving two terms from 1789 to 1797. His retirement was short, for he died at Mount Vernon on 14th December 1799.

An eminent French portrait sculptor, Jean Antoine Houdon was born in 1741. The list of his portraits is a roster of the great names of the late eighteenth century. He crossed the Atlantic in company with Benjamin Franklin at the instance of Thomas Jefferson to create the original of this statue in 1785. He died in 1828.

Waterlow, Sir Sydney, 1st Baronet 1822–1906.

Westminster School, Palace Street.
Sculptor Frank M. Taubman.
Erected 1900.

A bronze statue on a stone pedestal. Sir Sydney is shown standing, holding his hat and rolled umbrella in his right hand. The inscription on the pedestal says: 'Sir Sydney Hedley Waterlow. Baronet. Chairman of the Board of Governors 1873–1906.' The statue, a gift of Lady Waterlow, is a replica of that which stands in Waterlow Park, Highgate.

Sydney Hedley Waterlow was born in London on 1st November 1822 and educated at Brighton and Southwark. He entered his father's stationery business and started a printing department. This developed into the firm of Waterlow and Sons. He became Lord Mayor of London 1872–3, and was created a Baronet. He was a Member of Parliament from 1874 to 1885. His house and grounds at Highgate, now known as Waterlow Park, were presented to the public. He died on 3rd August 1906.

Frank Mowbray Taubman was born in London in 1868 and studied in London, Paris and Brussels. After working in London for some years he settled in Kemerton, where he died in 1946.

114

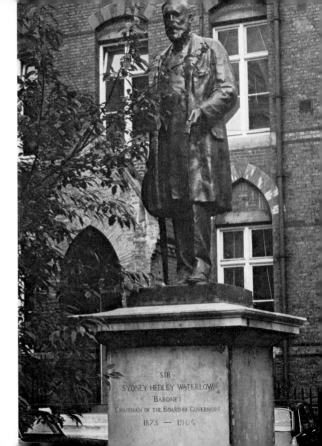

Wellington, 1st Duke of 1769–1852.

Hyde Park Corner.
Sculptor Sir Joseph Edgar Boehm.
Unveiled December 1888.

A bronze equestrian statue on a pedestal of red granite
on a grey granite base. The Duke is shown seated on
his horse, Copenhagen. He is wearing a cocked hat
and undress uniform and holding an open telescope
in his right hand and the reins in his left. At the
corners stand four figures: a Grenadier, a Highlander,
a Welsh Fusilier and an Inniskilling Dragoon. The
pedestal bears his name and dates of birth and death.
The monument replaced the Triumphal Arch by
Decimus Burton which was removed to Constitutional
Hill in 1883.

Arthur Wellesley, often regarded as Britain's greatest
soldier, was the fourth son of Garrett Wellesley,
1st Earl of Mornington. He was born on 29th April
1769 in Ireland and educated at Eton, Brussels and
Angers Military Academy. He served in the
Walcheren Expedition and established his reputation
in India with the battles of Seringapatam and Assaye.
As Commander-in-Chief in the Peninsular War he
won the series of victories which drove Napoleon's
forces first out of Portugal and then out of Spain.
His military career was crowned by his victory in the

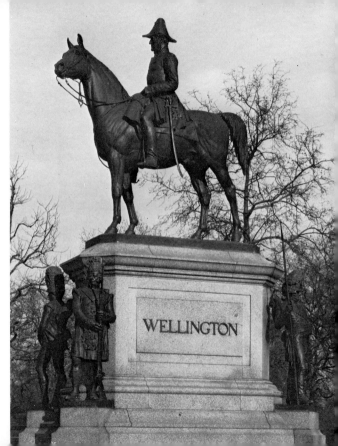

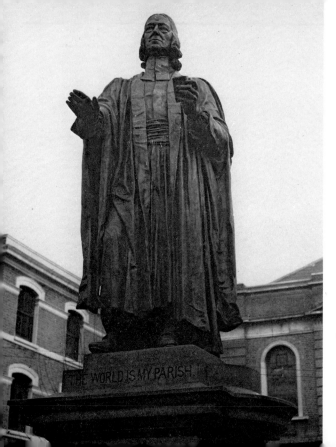

THE WORLD IS MY PARISH.

battle of Waterloo in 1815. Created 1st Duke of Wellington in 1814, he entered politics, becoming Prime Minister in 1830, and until his death remained the best known figure in the country. He died in 1852 and was buried in St Paul's Cathedral, where his ornate funeral carriage can still be seen.

Other Wellington memorials are: an equestrian statue by Sir Francis Chantrey, erected in 1844 in front of the Royal Exchange; the Achilles statue by Sir Richard Westmacott, erected in 1822 in Hyde Park and, according to the inscription, 'inscribed by the women of England to Arthur, Duke of Wellington and his brave companions in arms'; and an unmounted figure by T. Milnes which stood originally near the Tower of London but was removed to the Royal Arsenal at Woolwich in 1863.

For sculptor see page 23.

Wesley, John 1703–91.
City Road Chapel, Finsbury.
Sculptor John Adams Acton.
Erected 1891, on the centenary of his death.

A bronze statue on a pedestal of polished red granite on a grey granite base. Wesley is shown standing, holding a book in his left hand, his right hand open and extended. There is an inscription at the base: 'The World is my Parish.'

John Wesley was the younger son of Samuel Wesley (originally Westley), divine and poet, and was born at Epworth Rectory, Lincolnshire, on 17th June 1703. He was educated at Charterhouse and Christ Church, Oxford. He entered the Church and served as curate for his father at Wroot and then from 1729 to 1735 he was tutor at Lincoln College, Oxford. During this time he became leader of his brother Charles Wesley's Methodist Society in Oxford. He went with his brother on a mission to Georgia and became much influenced by German Moravian brethren, a doctrine which he later abandoned. He opened the first Methodist chapel in Bristol in 1739 and another in London later the same year. Wesley travelled many thousands of miles, preaching and organizing his followers into societies. Methodism spread rapidly throughout the country. He also published many collections of hymns. He died at his home at 47 City Road, London, on 2nd March 1791.

John Adams Acton was born in Middlesex in 1834.

He exhibited at the Royal Academy from 1854 to 1868 under the name of John Adams and from then until 1892 he used his full name.

White, Sir George 1835–1912 (p. 118).

Portland Place.
Sculptor John Tweed.
Erected 1922.

A bronze equestrian statue on a pedestal of Portland stone. White is shown in the uniform of a Field Marshal and wearing a plumed hat. The pedestal bears his name and awards and dates of birth and death. The statue was originally intended for Horse Guards Parade.

George Stuart White was born at Whitehall, County Antrim, on 6th July 1835 and educated at Sandhurst. He joined the Inniskillings in 1853 and served with them during the Indian Mutiny. In the second Afghan War he led the Gordon Highlanders at the battle of Charasiah and was awarded the Victoria Cross. He became a Major-General in 1889 and succeeded Lord Roberts as Commander-in-Chief, India, in

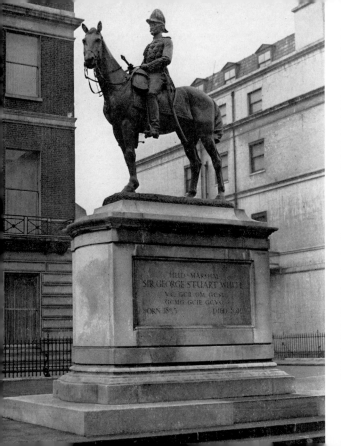

1893. In the South African War he defended Ladysmith during the siege. From 1900 to 1904 White was Governor of Gibraltar; he became a Field Marshal in 1903. He died on 24th June 1912.

John Tweed was born in 1869 and studied under Ewing in Glasgow, Thornycroft in London and Falguière in Paris, where he was also befriended by Rodin. Many of his statues were of founders of the British Empire and were erected in India and South Africa. He died in 1933.

William III, King 1650–1702.
St James's Square, Pall Mall.
Sculptor John Bacon, the younger.

A bronze equestrian statue on a stone pedestal. The King is shown in Roman costume. In his will Samuel Travers said: 'I will and bequeath a sufficient sum of money to purchase and erect in St James's Square an equestrian statue in brass to the glorious memory of my master King William the Third.' The pedestal was erected in about 1732 but remained without a statue until 1808.

118

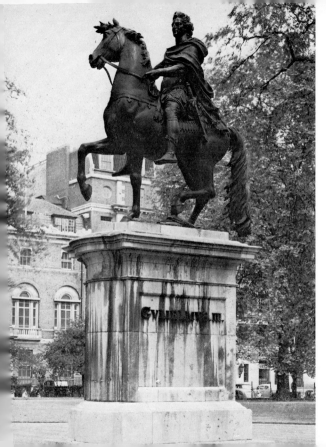

William, Prince of Orange, was the son of William, Prince of Orange, and Mary, daughter of Charles I. He was born at the Hague on 4th November 1650 and educated at Leyden. In 1677 he married Mary, daughter of James, Duke of York, (afterwards James II of England). When James II's Catholic and pro-French tendencies made him unpopular it was arranged that William should invade England. He landed at Brixham on 5th November 1688 and after the flight of James accepted the throne jointly with Mary. They formed an alliance with the Dutch and defeated James at the Battle of the Boyne in 1690. After the death of Mary in 1694 William ruled alone for eight years. He died from the effects of a riding accident at Hampton Court in 1702 and was buried in Westminster Abbey.

There is another statue of William III at Kensington Palace.

John Bacon, the younger, the second son of John Bacon, R.A., was born in 1777 and died in 1859. He studied at the Royal Academy Schools but was not considered as great a sculptor as his father, who designed this statue.

119

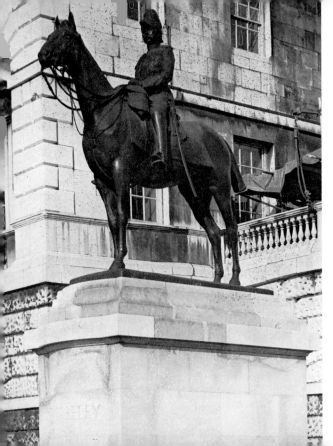

Wolseley, 1st Viscount 1833–1913.

Horse Guards Parade.
Sculptor Sir William Goscombe John.
Unveiled 1920.

A bronze equestrian statue, on a stone pedestal, showing the Viscount in the uniform of a Field Marshal and holding a baton in his right hand. The inscription on the pedestal gives his name, rank, dates and honours and concludes: 'This statue cast from metal of guns taken in Lord Wolseley's campaigns was erected by public subscription.'

Garnet Joseph Wolseley was born at Golden Bridge House, County Dublin, on 4th June 1833. He entered the Army in 1852 and had a long career of active service, taking part in the Burmese War, the Crimean War and the Indian Mutiny. By 1859 he was a Lieutenant-Colonel, having served in four campaigns, been four times wounded and mentioned nine times in dispatches. Later he served in the Ashanti War, and in Egypt won the battle of Tel el-Kebir in 1882 and commanded the expedition which attempted to relieve General Gordon. He was made Field Marshal in 1894 and from 1895 to 1900 was Commander-in-Chief. In 1885 he was created Viscount. Throughout his career he worked for army reform. Wolseley was the original of W. S. Gilbert's

'modern major-general' in *The Pirates of Penzance*.
He died at Menton, France, on 25th March 1913
and was buried in St Paul's Cathedral, London.

Sir William Goscombe John, R.A., one of the most
distinguished sculptors of his time, was born in
Cardiff in 1860 and exhibited at the Royal Academy
from 1886. He was a prolific worker and his statues
of statesmen are to be seen throughout the country
and the Commonwealth, including memorials in a
number of cathedrals. He died in 1953.

York, Duke of 1763–1827.

Waterloo Place.
Sculptor Sir Richard Westmacott.

The column was completed in 1833 and the statue
placed in position on 8th April 1834.

The statue is of bronze and is mounted on a Tuscan
column 124 feet high, made of granite and designed
by Matthew Wyatt. The Duke is shown in uniform,
with a cloak and with his right hand on his sword.
The statue is placed so high, however, that it is
difficult to see much detail. Inside the column is a
spiral staircase. To provide funds for the monument
every officer and soldier in the Army contributed
a day's pay.

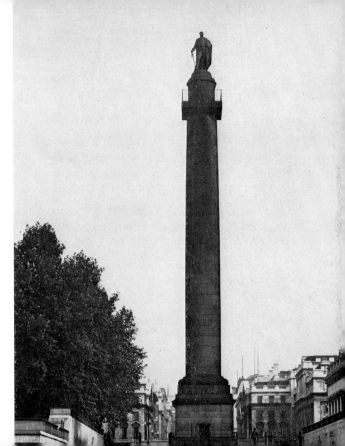

121

Prince Frederick Augustus, the second son of George III, was born at Osnabrück on 16th August 1763. He was created Duke of York in 1784, entered the Army and trained in Germany. In 1791 he married the eldest daughter of Frederick William II of Prussia. He enjoyed considerable success in his military career, eventually becoming Commander-in-Chief, and was beloved by his men because of his continued efforts to improve their conditions. His success was marred, however, by two incidents: the unsuccessful Helder Expedition and the inquiry into the alleged selling of commissions by his mistress, Mrs Mary Anne Clarke. On this charge the Duke was found to be without blame. He died in Arlington Street, London, on 5th January 1827, lay in state in St James's Palace and was buried in St George's Chapel, Windsor.

For sculptor see page 19.

Statues in other parts of London

Alexandra, Queen.
Consort of Edward VII.
Behind London Hospital, Whitechapel Road.
George Wade, 1908.

Aske, Robert.
Leader of the Catholic 'Pilgrimage of Grace'.
In the grounds of Haberdashers' Aske's Boys' School, Hatcham. Formerly at the school in Hoxton; removed to its present site in 1898.
Sculptor unknown.

Bevington, Colonel S. B.
First Mayor of Bermondsey.
Tooley Street, Bermondsey.
Sydney March, 1910.

Booth, General William.
Founder of the Salvation Army.
William Booth Memorial Training College, Denmark Hill.
George Wade, 1929.

Booth, Mrs Catherine.
'Mother' of the Salvation Army.
William Booth Memorial Training College,
Denmark Hill.
George Wade, 1929.

Cartwright, John.
Reformer.
Cartwright Gardens, Euston Road.
G. Clarke, 1831.

Churchill, Sir Winston Leonard Spencer.
Statesman.
1 Woodford Green.
2 Members' Lobby of the House of Commons.
3 Westerham, Kent.
4 Inside Guildhall.
Number *1* is by David McFall, 1959, and numbers
2, *3*, and *4* are all by Oscar Nemon.
An outdoor statue is soon to be erected in central
London.

Cobden, Richard.
Statesman.
High Street, Camden Town.
W. and T. Wills, 1868.

Colet, John.
Scholar and churchman.
St Paul's School.
Sir (William) Hamo Thornycroft. Erected 1902,
when the school was at Hammersmith. Moved with
the school in 1969.

Fawcett, Henry.
Statesman.
Vauxhall Park.
G. Tinworth, 1893.

Green, Richard.
Shipowner and philanthropist.
East India Dock Road.
Edward W. Wyon, 1866.

Holland, Henry Richard Fox, 3rd Baron.
Holland Park, Kensington.
G. F. Watts and Sir Joseph Edgar Boehm, 1872.

Myddleton, Sir Hugh.
Merchant, originator of the 'New River' project.
Islington Green.
John Thomas, 1862.

Napoleon, Prince.
The Prince Imperial.
Royal Military Academy, Woolwich.
Count Gleichen, 1883.

Siddons, Sarah.
Actress.
Paddington Green.
Chavalliaud, 1897.

Sloane, Sir Hans.
Physician and botanist.
Chelsea Botanic Garden.
Michael Rysbrach, 1737.

Todd, Robert Bentley.
Physician.
King's College Hospital, Denmark Hill.
Matthew Noble, 1862.

Watts, Dr Isaac.
Hymn writer.
Abney Park Cemetery.
E. H. Baily, 1845.

Whittington, Richard.
Mayor of London.
Whittington College, Archway Road, Highgate.
Sculptor unknown, *c.* 1827.

William IV, King.
Greenwich Park. First erected in King William Street
in 1844, it was removed to its present site in 1936.
Designed by Richard Kelsey.
Sculptor, Samuel Nixon.

Wolfe, General James.
Greenwich Park.
R. Tait McKenzie, 1930.

Index to Sculptors
(Bold figures refer to pages with biographical details)